IMAGES
of America

KAY COUNTY'S HISTORIC
ARCHITECTURE

IMAGES
of America

KAY COUNTY'S HISTORIC
ARCHITECTURE

Bret A. Carter

ARCADIA
PUBLISHING

Published by Arcadia Publishing
Charleston SC, Chicago IL, Portsmouth NH, San Francisco CA

Printed in the United States of America

Library of Congress Catalog Card Number: 2006940476

For all general information contact Arcadia Publishing at:
Telephone 843-853-2070
Fax 843-853-0044
E-mail sales@arcadiapublishing.com
For customer service and orders:
Toll-Free 1-888-313-2665

Visit us on the Internet at www.arcadiapublishing.com

Kay County's Historic Architecture *is dedicated to those who
inspired my interest in historic buildings and those who
have helped me learn about their history and how to preserve
them. This work is also dedicated to my loving and tolerant
wife, Michelle, without whose constant help and support
all my accomplishments would be impossible.*

CONTENTS

ACKNOWLEDGMENTS

The preservation and sharing of the histories of local communities, particularly those that have a small population, would not happen without a few dedicated people who have made the preservation of those histories a daily commitment. It would have been impossible to write this book without the help and support of Darlene Pratt, Marland's Grand Home, Ponca City; David Keathly and Connie Pruitt, the Marland Mansion, Ponca City; Jerry Johnston, Braman; Karen Dye, Newkirk Main Street, Newkirk; L. V. Crow, Friends of Nardin, Nardin; Louise McDonagh, Pioneer Woman Museum, Ponca City; Mark Evans, Blackwell Journal Tribune; Rex Ackerson, Northern Oklahoma College, Tonkawa; Virginia Loney, Kaw City Museum; Melvena Heisch, Catherine Montgomery, and Jim Gabbert, all of the Oklahoma State Historic Preservation Office; Todd Scott, formerly of the Oklahoma Main Street Program; Ron Frantz, Oklahoma Main Street Program; Verona Mair, Ponca City Landmark Conservancy; Paula Denson of Ponca City; and Heather Siefert, Preservation Oklahoma. To all these and the volunteers who give countless hours toward preserving the history of Kay County communities at the many museums, and to all those who have made historic preservation a priority in their individual lives, this book is dedicated. Thanks also to the Blackwell Times-Record, Ponca City Democrat, Ponca City News, and Tonkawa News for historic information.

A special acknowledgement is due to Ray and Velma Falconer, whose preservation of historic images of Ponca City is appreciated. And also to Laura Streich, whose research into the history of Ponca City and Kay County ended with her untimely death, but has provided me and other historians with information and inspiration.

Their efforts are quite often unrewarded and unrecognized, but the efforts of these people, and their willingness to share the fruits of their countless hours of collecting, cataloging, researching, and preserving the artifacts of our past are so important. Without their efforts, we would have no knowledge of our history and would be unable to understand the relationship between ourselves and the people who built these wonderful buildings.

Also, I have to acknowledge the help of my wife, Michelle, mother Sondra Swaggart, Tracy Davis McCloud, Jane Rager, and Lori Hutchins, who helped transform my meager attempts at writing something that was interesting into something that was grammatically correct, easy to read, and hopefully still interesting. They are responsible for all that is good and correct within these covers while any flaws are entirely my own.

INTRODUCTION

Buildings are reminders of everything that was part of life in the days when they were built. They reflect local events as well as those that occur nationally or internationally. Primarily, buildings everywhere reflect the economy of the communities and the people who built them. The earliest buildings in Kay County were related to the Native American tribes who inhabited the county, or were associated with the efforts of the United States government in its efforts to control and educate the tribal members.

Chilocco Indian School was one of the first Indian boarding schools in the United States, and was also the largest. The very first Chilocco building was designed by John G. Haskell, who also designed the Kansas State Capitol. The campus grew from one building in the mid-1880s to over 60 by 1980, most of native limestone. Leupp Hall, Haworth Hall, and the old hospital building on the campus all date to before Oklahoma became a state in 1907. However, of the buildings erected on the campus before the land run of 1893, only the hospital remains. The entire school has been listed on the National Register of Historic Places, through the efforts of the alumni association and the Council of Confederated Chilocco Tribes. At White Eagle, the center of the Ponca Reservation, there were several buildings that were associated with the Ponca Indian Agency. None of these buildings remain today. The Kaw Agency building, built in 1873, still remains and is listed on the National Register of Historic Places. Washunga was the site of the Washunga Indian Boarding School.

Some of the earliest buildings in Kay County are reminders of a time when the newly arrived white residents were struggling to make a new life, as was the case in the late 19th century following the 1893 land run. Between 1893 and 1900, many buildings were largely utilitarian and were constructed of the most basic and available materials. Dugouts, sod huts, or simple stone structures were common. Many a homesteading family lived for at least a few months and sometimes for years in these simple structures. The first significant buildings constructed on the farms were usually a barn, often erected with the help of neighbors. Early commercial buildings tended to be wood, often with a false front to give the appearance of a more substantial enterprise.

Only a few buildings found in the fledgling communities were of more than one story or of materials other than wood prior to 1900. In at least two of the new towns in Kay County (Newkirk, Ponca City), devastating fires destroyed significant parts of the downtown districts, causing these cities to require that downtown buildings be of stone or brick. Ponca City went so far as to ban the use of limestone, since even it could be destroyed by the fire.

Most of the earliest brick and stone buildings of Kay County are found in Blackwell and Newkirk. Blackwell was the largest and most prosperous community in Kay County until the

oil boom began, and the early masonry buildings there reflect that prosperity. Some date to 1895, two years after the land run. Newkirk had an economic advantage in that the county courthouse was located there, and there was an inclination for businesses to locate there as well. By 1900, the downtown district of Newkirk was predominantly of native stone. Ponca City, while the largest community today, did not have the same number of brick or stone buildings downtown until the early 1900s. A majority of residences in all the communities were of wood, in the folk vernacular style.

Gradually all the towns in Kay began to believe that having imposing schools and other public buildings would be beneficial to the efforts to promote the town to new residents. Commercial clubs, the forerunners of today's chambers of commerce, would publish town profiles complete with pictures of "the fine residential district" or the "new $30,000 School," all geared to "boost" the community's image. This boosterism was considered essential. Many towns established in Kay County died during those early years, and the constant effort to boost the image of each community was viewed as the only antidote to seeing one's hometown share that fate. However, as history reveals, it was not the creation of spectacular buildings that would help these communities become more prosperous or successful in recruiting new businesses, but the growth of businesses that would create the prosperity to create more substantial buildings.

From 1893 to 1915, few buildings in the county were built with the assistance of a university-trained architect. Most were constructed by very competent local builders. Builder O. F. Keck of Ponca City left a major impact on Ponca City and the county. Keck built nearly every building on Grand Avenue in Ponca City, from the Calkins Building at 101 West Grand Avenue to the city's Civic Center Auditorium at 516 East Grand Avenue. Also, Keck was the builder for Central Hall at the University Preparatory School in Tonkawa (today's Northern Oklahoma College). James Gammie, also of Ponca City, was a talented Scottish stone mason and constructed several stone buildings in Ponca City during the early 1900s, including the Brett Building at 100 East Grand Avenue. Nehemiah M. Tubbs of Newkirk left his mark in stone in that community. Other builders in the county created unique and lasting works of architecture during this time but remain unknown today.

However, when someone had both money and desire, architects could be called upon to provide the plans. W. L. McAltee, a very competent architect, designed Blackwell's Beaux-Arts Electric Park Pavilion, a spectacular boosterism building. One of the most prolific architects in the growing state was Solomon Andrew Layton and his various partners of El Reno, Oklahoma, and later of Oklahoma City. They left many imposing buildings in the county during those early years, including the Carnegie Library, Farmer's National Bank, three mansions, and the Civic Center Auditorium, all in Ponca City, as well as Wilken Hall at the University Preparatory School (now Northern Oklahoma College) in Tonkawa. Layton and his partners would go on to design the Oklahoma State Capitol. Other buildings show signs of being designed by the hand of a professional architect, but much more research is required in order to determine who these creative individuals were.

The era of sustenance and boosterism was abruptly changed with the discovery of oil deposits in Kay County. While buildings continued to be built of the most rudimentary materials or for the express purpose of promoting the image of a community, the rivers of oil money that flowed through the county affected the architecture of every community. The period from 1916 until the beginning of the Great Depression in 1929 would see the construction of more imposing homes, bigger commercial buildings, and larger schools. As the days of mere survival faded into memory and most of the county's towns looked toward a future anchored with the flow of oil-field wealth, more experimentation in the design of new buildings as well as use of the increasing variety of available construction materials and components was common.

This is apparent in most of the communities in Kay County, with the exception of those that had economies based entirely in agrarian pursuits. Artistic and creative architectural designs of these days include the Kay County Courthouse, North Hall (Tonkawa Northern Oklahoma College), and the Tonkawa Masonic Lodge. With its glass dome, the First Presbyterian Church in

Ponca City was among the most interesting buildings in the county during this optimistic time. The spectacular Marland Home in Ponca City, with one of the first indoor swimming pools in Oklahoma, certainly set a high standard for other wealthy individuals. It was also during this time that the five-story Masonic building (Blackwell), and the Rivoli Theater (also in Blackwell) were built. The Ponca City Civic Center Complex finally reached its full Spanish Revival potential during the 1920s. Many residences in Braman, Blackwell, Tonkawa, Kaw City, and Newkirk reflected the personal wealth extracted from the ground in the oil fields of northern Oklahoma. It would seem that oil was converted to architecture nearly as fast as it could be pulled from the earth, resulting in many beautiful churches, schools, civic and commercial buildings, and homes that are enjoyed to this day.

Architects who helped shape buildings during the 1916–1929 time frame included George Cannon of Ponca City, Solomon Andrew Layton, Smith and Senter, John Duncan Forsyth, Clyde Woodruff, and Hawk and Parr. Layton and his partners designed the civic center expansion in Ponca City as well as the Marland home and the Ponca City Moose Lodge building. Cannon designed many buildings and homes in Ponca City including the Soldani Mansion and the Savage Motor Company building. Smith and Senter were responsible for the Ponca City Masonic Building and several Ponca City schools including Garfield and the Ponca City High School. Hawk and Parr were called upon to create the jewel-box Tonkawa Masonic Lodge. Architects, with their ability to create buildings that expressed the full range of architectural emotion from the restrained quietness of the Ponca City Christian Scientist Church to the exciting Wentz Camp and Pool, were instrumental in creating buildings that reflected the vibrant era.

As the oil boom years quickly faded into the days of the Great Depression and then World War II, the few buildings that were constructed continued to mirror the lives of those who built them. And that life, in some ways, seemed to be one of sustenance much like that experienced by the previous generation of land run days. The shock of the depression following the exuberance of the oil boom was reflected in architecture. Kay County residents went from the flashiness of buildings like the Marland Mansion to the somberness of buildings like the Tonkawa Public Library. During the time from the beginning of the Depression in 1929 until the end of World War II, few buildings were built that reflected great or even modest wealth. Even the boosterism architecture of the early times was rare. About the only bright spots, architecturally, were the buildings built as Civilian Conservation Corps (CCC) or Works Progress Administration (WPA) projects. Tonkawa and Ponca City were beneficiaries of WPA-financed libraries. Tonkawa and Blackwell were endowed with WPA-built armories, both now listed on the National Register of Historic Places. The CCC began the construction of the fine rustic buildings at Lake Ponca Park that were completed by WPA. Ironically it was due to the election of Kay County's own E. W. Marland as governor that any CCC or WPA projects were allowed in Oklahoma at all. Oklahoma's previous governor had refused to allow the CCC to work in Oklahoma, a viewpoint that Governor Marland believed was detrimental to the financial survival of many families in the state.

It was during this time that new construction nearly stopped in the mostly agricultural communities of Braman, Nardin, Peckham, Kildare, and in Newkirk to some degree. The lack of finances was, in a sad way, responsible for the preservation of many of the early buildings in those communities.

Although architects suffered just as everyone else during this era, the WPA projects helped them survive. M. D. Timberlake of Ponca City began to see commissions during this time and would go on to be one of the most prolific architects in Kay County. Also, George Cannon of Ponca City continued to be active and designed many new buildings, including the Ponca City Library. John Duncan Forsyth, creator of the Marland Mansion, drafted the design for the Ponca City Post Office during the Depression years. While the name of the architect who was responsible is unknown, it is probable that Chilocco's Home 4 and Home 3 were architect designed.

With the end of the war, architecture took another unusual turn in Kay County. Blackwell set a new national standard for grade school design when they hired Caudill and Rowlett of College

Station, Texas, to design four new grade schools there. Those schools, particularly Huston and Washington, were cited across the county as ground-breaking concepts in educational architecture, and are considered significant examples of mid-century architecture to this day.

M. D. Timberlake of Ponca City was also active in the county during this era and was responsible for the very modern Southwestern Bell Telephone dial building in Ponca City. He and his partner would reshape the architecture of the Ponca City School System with designs for new buildings or remodeling of nearly every school in the system.

Some other spectacularly successful buildings of the mid-century in Kay County include the Blackwell public pool, the Blackwell Zinc Union's Kennedy Memorial Hall, and a multitude of private residences.

It is the hope of the author that the readers, as they drive down the seemingly familiar streets of their hometown in Kay County (or as they visit the towns of Kay County) will see the buildings along their way in a new light, realizing that they are "frozen history."

Buildings selected for inclusion in this book had to have been built over 50 years ago. To show the broad scope of buildings that graced communities in Kay County, we have included buildings that no longer exist. Inclusion in this book does not mean that a building is eligible for the national register, only that it is old enough for such listing.

All images that were provided by others have an acknowledgement of that generosity in the captions; where no such acknowledgement is stated, the images are from the collection of the author.

If a building is no longer standing, that is indicated in the caption for that picture; those that are existing or where their status is unknown have no note regarding that.

One

SUSTENANCE AND BOOSTERISM
BUILDINGS BEFORE 1916

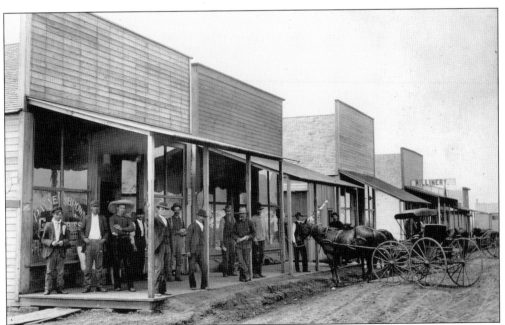

BRAMAN STREET SCENE. Braman got a late start and was surveyed and platted by Dwight Braman, then incorporated in 1899. In 1901, it looked like the other towns in Kay County had seven years earlier. The wood false-front buildings with sloped awnings that extended to wood posts set at the edge of the street were a common type of building in Kay County downtowns for the years prior to about 1900. (Courtesy of Jerry Johnston.)

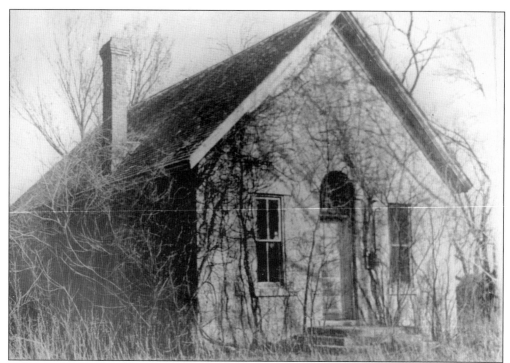

KAW AGENCY BUILDING. This simple stone structure served as the primary contact point between the white man and the Kaw Indians following its construction in 1873. A simple gable-front building, its only decoration is the arched entry with large fanlight. (Courtesy of Marland's Grand Home.)

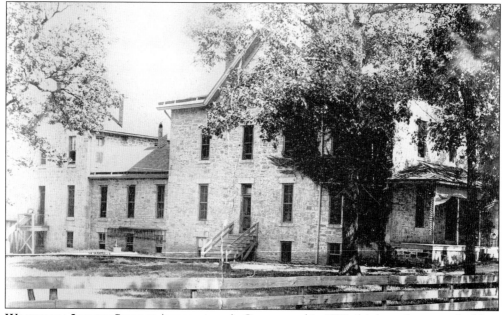

WASHUNGA INDIAN SCHOOL (DEMOLISHED). Constructed in 1893, this large four-story building of native stone served as a dormitory for the Washunga Indian Boarding School. The building burned in 1910 but was reconstructed as a school later. (Courtesy of Marland's Grand Home.)

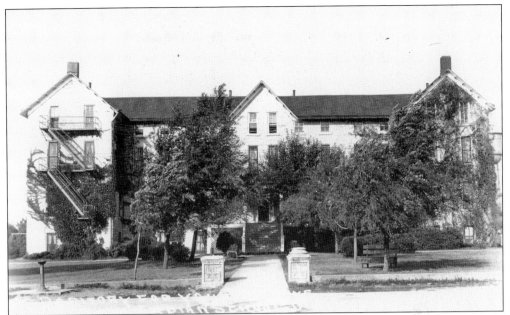

HOME 2, CHILOCCO (DEMOLISHED). Following his initial visit to the Cherokee Outlet to find a location and obtaining government funding, Maj. James Haworth contracted for the construction of the original building at the Chilocco Indian School in 1883. It was designed by John G. Haskell, who also designed the Kansas State Capitol.

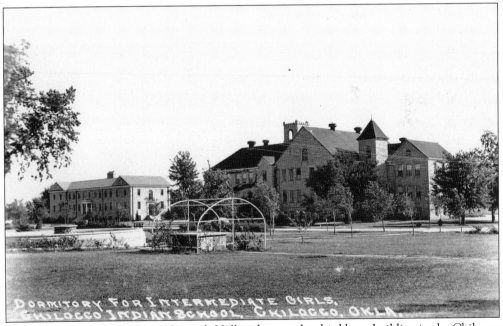

HAWORTH HALL, CHILOCCO. Haworth Hall, right, was the third large building in the Chilocco Indian School and provided classroom space and a large auditorium. It was constructed in 1907 after the original Haworth Hall burned. The tower at the right entry was later removed. The substantial modified Romanesque architecture of the campus provided a sense of security to the students.

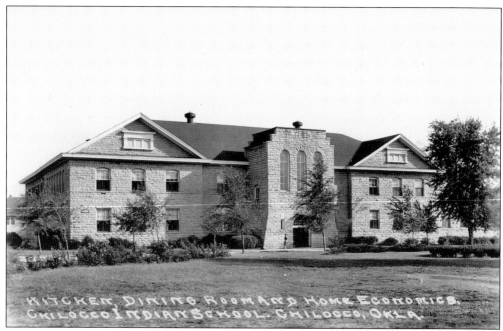

LEUPP HALL, CHILOCCO. Constructed in 1905, Leupp Hall, with its observation tower over the front entry (later removed), housed the dining hall and kitchens for the school and provided additional classroom space for the growing school. The three arched windows on the facade over the entry, as well as the arch door and locally quarried limestone construction, are evocative of the Romanesque Revival style of architecture.

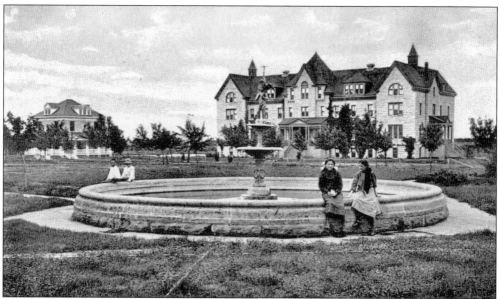

DORMITORY AND FOUNTAIN, CHILOCCO (DEMOLISHED). With its fanciful gables and arched windows, this large three-story building on the east side of the oval at Chilocco was home to thousands of American Indian children from the date of its construction until its eventual demolition in the 1960s. This was one of two dormitories on the campus of similar design.

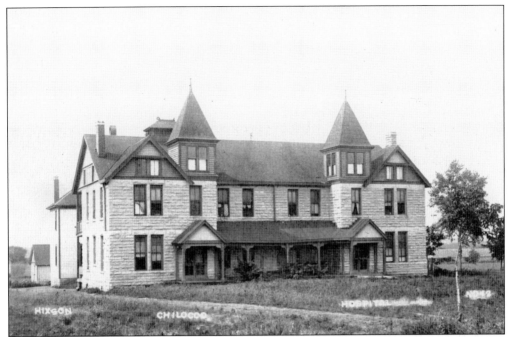

HOSPITAL, CHILOCCO. The original hospital at Chilocco was this grand building, constructed of the same native limestone as the other original buildings. It was located across the lake from the campus proper to prevent the spread of contagious diseases. The rusticated stone, pyramidal towers and belt courses above and below the main floor windows were the only decoration, yet this building is quite pleasing in appearance.

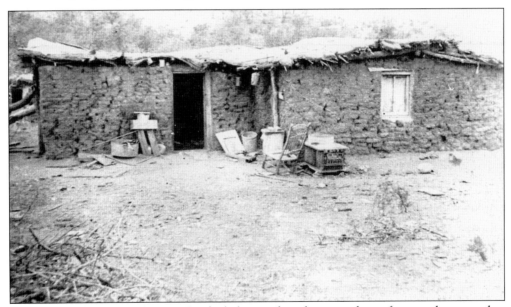

CHEROKEE OUTLET SOD HOUSE. Crude shelters such as these were home for many homesteaders after the 1893 land run. Dried sod was one way to build shelter in the quickest possible way that first fall. Crude as they were, they still provided a place for winter dances and other entertainments for the homesteader families. (Courtesy of L. V. Crow, Friends of Nardin.)

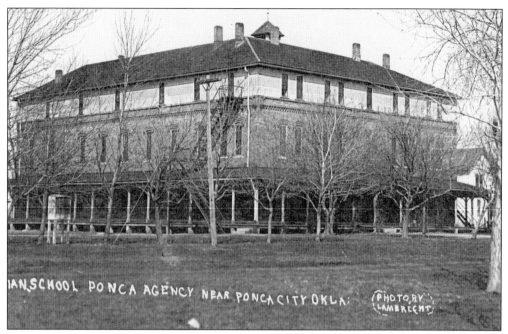

IAN SCHOOL PONCA AGENCY NEAR PONCA CITY OKLA. (PHOTO BY LAMBRECHT)

WHITE EAGLE INDIAN BUILDINGS AGENCY (DEMOLISHED). The Ponca Tribe was relocated to the Cherokee Outlet from Nebraska and South Dakota between 1876 and 1878. The school at White Eagle served to educate the American Indian children from the time of its construction in 1880 until it was closed in 1919. Its construction provided jobs for about 50 American Indians. The main agency building served as the center of the reservation. All of the agency buildings at White Eagle were surrounded by immaculate white picket fences, as shown in the images.

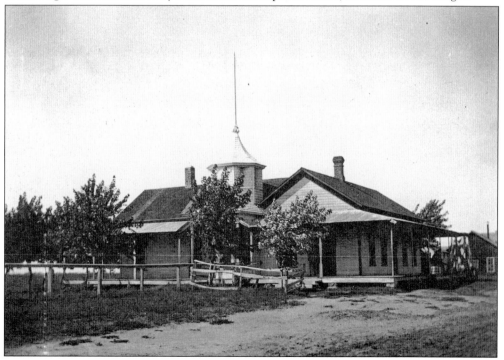

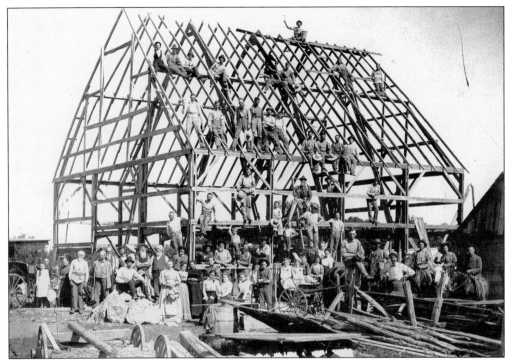

BARN RAISING, BLACKWELL AREA. Sometimes with nothing more than spirit and commitment, and the help of nearby farmers, substantial buildings were erected. Here the many volunteer carpenters are posed on the framing for this large barn. Hard as the work was, barn raising also served as an important social event. (Courtesy of the Top of Oklahoma Museum.)

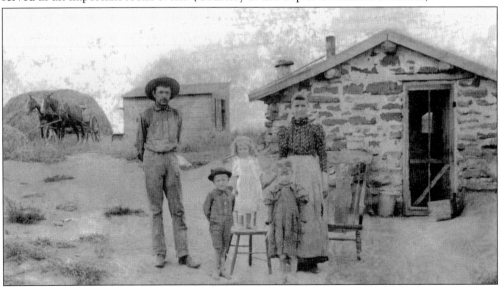

EARLY STONE CABIN, NARDIN VICINITY. While sod houses were common, rarely were the materials available to build a stronger cabin of stone. However, as the residents of Newkirk and Ponca City (and the Blue family of the Nardin area as shown here) were to find out, rich limestone deposits existed under some areas of the endless prairie and were suitable as building materials. (Courtesy of L. V. Crow, Friends of Nardin.)

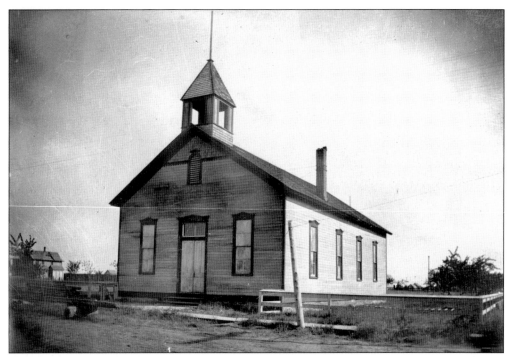

FIRST SCHOOL, PONCA CITY (DEMOLISHED). On November 16, 1883, only two months after the founding of Ponca City, a handful of students attended school in this simple frame building. The school, with its painted white fence, represented the commitment of the citizens to be a town of the first class. This was the first of four schools to be built on the site.

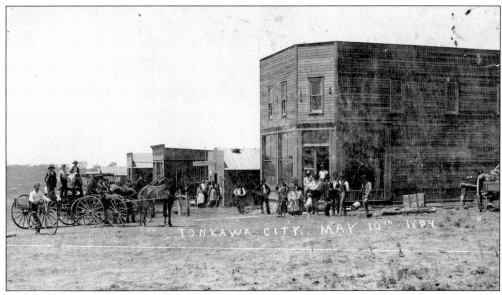

TONKAWA DOWNTOWN. Tonkawa was granted a post office on March 9, 1894, two months before this picture was taken in May of that year. The first two years in the fledgling towns of Kay County were times of shortage for man and livestock due to a drought, and Tonkawa did not begin to truly thrive until 1897. (Courtesy of the Tonkawa Historical Society.)

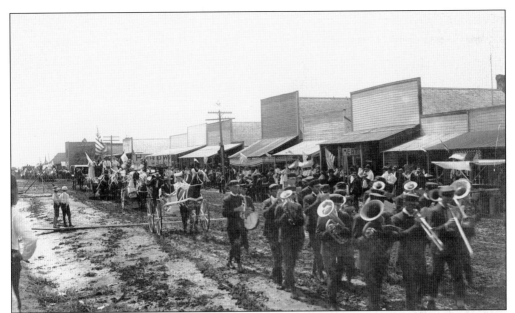

BRAMAN CHEROKEE STRIP PARADE. While the date of this picture is unknown, it portrays so many aspects of early life in Kay County towns. While the community members celebrate the Cherokee Strip anniversary with a band and parade, one can see the difficulties of everyday life in the rain-soaked mud streets and the simple board used to cross the treacherous mud from one side to the other. (Courtesy of Jerry Johnston.)

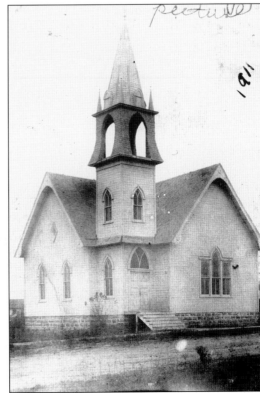

FIRST CHRISTIAN CHURCH, KAW CITY. This wood frame building was constructed in 1904 and served as the house of worship for the Christian Church congregation until the lake was built in 1971. In the Gothic Revival style popular for churches of the era, it featured lancet pointed arches and a unique multilevel bell tower. (Courtesy of the Kaw City Museum.)

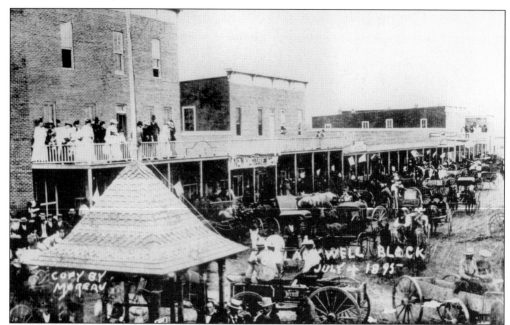

BLACKWELL DOWNTOWN. Originally called Parker, the town of Blackwell quickly grew into the largest town in Kay County and by 1902 boasted three railroads, seven saloons, and an Anheuser-Busch brewery. This picture, taken on July 4, 1894, shows the fine brick buildings constructed within a year of the land run. The gazebo at the lower left is the town well and graces the grounds of the Top of Oklahoma Museum today.

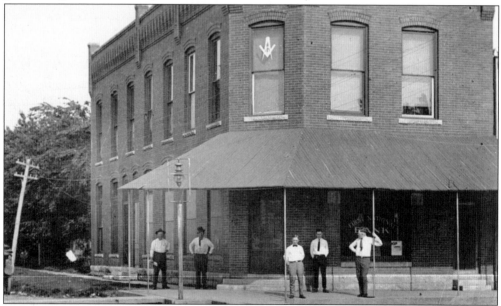

BRAMAN MASONIC BUILDING. This fine brick building, in the early commercial style so prevalent at the beginning of the 20th century showed that the small community was complete in every way, including having a large Masonic organization. The building serves Braman citizens to this day as the home of the Braman museum. The building was constructed by H. E. Martin of Blackwell for a cost of $5,000 in 1905. (Courtesy of Jerry Johnston.)

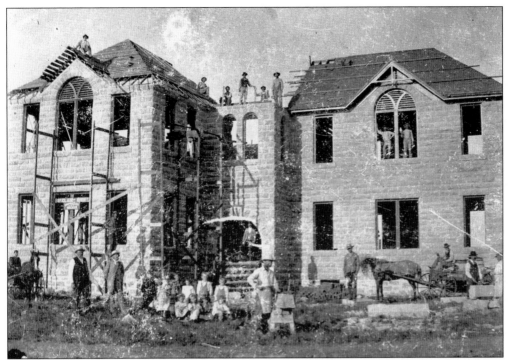

PONCA CITY'S FIRST STONE SCHOOL. In 1896, three years after the land run, Ponca City residents began construction of this school, using locally quarried limestone. The Romanesque Revival–style building sat on the same lot as the earlier frame school and cost $30,000 to build. Large arched windows and a three-story bell tower helped create the grand impression this school created. The building was enlarged in 1899 and served all grades of students until 1905, when a new high school was constructed. The school was destroyed by fire on January 2, 1911.

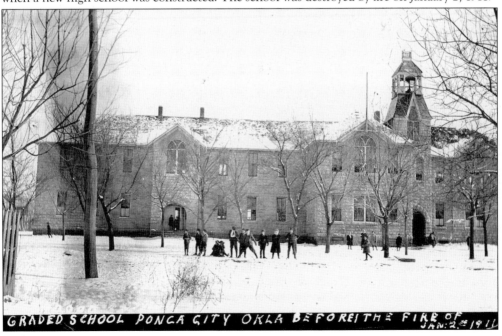

GRADED SCHOOL PONCA CITY OKLA BEFORE THE FIRE OF JAN. 2 1911

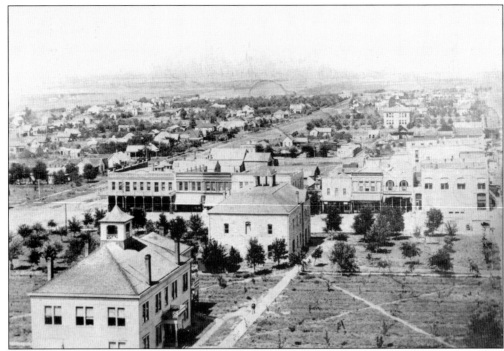

AERIAL VIEW OF DOWNTOWN NEWKIRK. The building at the lower left in this picture is the second Kay County Courthouse, constructed after fire destroyed the original building in 1897. In the center of the image is the Newkirk City Hall, and just at the right edge above the city hall is the Park Hotel. Of these three buildings, only the Park Hotel stands unaltered today. (Courtesy of Newkirk Main Street.)

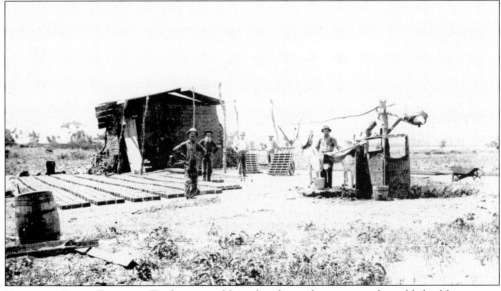

TONKAWA BRICK FACTORY. Tonkawa, not blessed with nearby reserves of suitable building stone, relied on a brick factory to provide hard fireproof brick for early commercial and residential buildings. The brick was laboriously made using crude forms (seen near the center) and available water and clay. (Courtesy of Tonkawa Historical Society.)

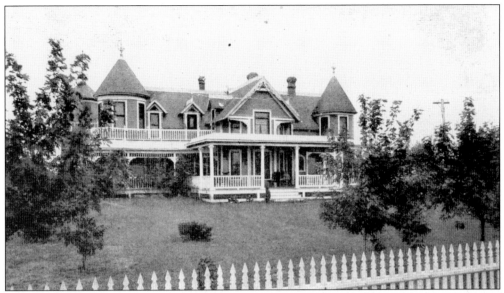

Peckham Residence, Blackwell (Demolished). Edward Peckham was an early resident of Blackwell and served the county well in his efforts to obtain railroads across the county. His efforts were rewarded with towns named for him (Peckham) and his son (Eddy). His Victorian house was palatial for early Kay County and sat resplendently inside a white picket fence.

Scolfield House, Newkirk. The M. E. Scolfield house is an unusual adaptation of the foursquare home, popular in the early 1900s. This 1901 home is constructed of stone and has several sets of Palladian windows, which are sets of three windows with the center one being arched. Originally the home had a porte cochere, appropriate for the owners of Newkirk's first automobile.

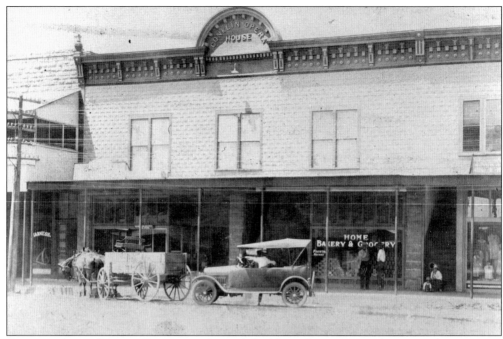

CONKLIN OPERA HOUSE, KAW CITY. This early building of Kaw City, in the vernacular Victorian style, was constructed of pressed metal siding with a decorative metal cornice. The unique half-circle name tablet at the top is decorated with a deep bracketed cornice. (Courtesy of Kaw City Museum.)

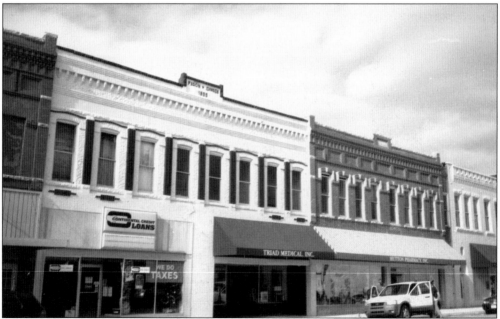

DOWNTOWN, BLACKWELL BUILDINGS. These two buildings, each with 50 feet of street frontage, were constructed in 1899 and make up nearly half of the 100 block of South Main Street. Joined on the north by two more buildings that date from before 1900, the collection of buildings is among the oldest brick buildings in Kay County.

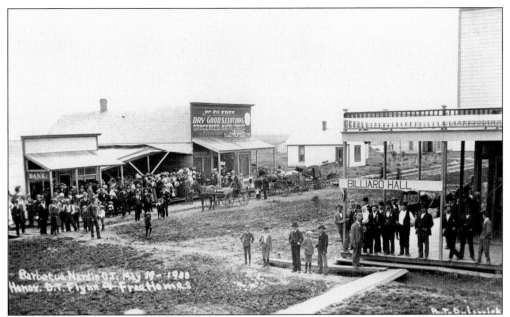

DOWNTOWN NARDIN (DEMOLISHED). With a bank on the left side, a dry-goods store near the center, and a hotel complete with a billiard hall, the Nardin of 1900 is a thriving agricultural community. Many of these early wood buildings were replaced with more substantial masonry buildings by 1905, as seen on page 50. (Courtesy of L. V. Crow, Friends of Nardin.)

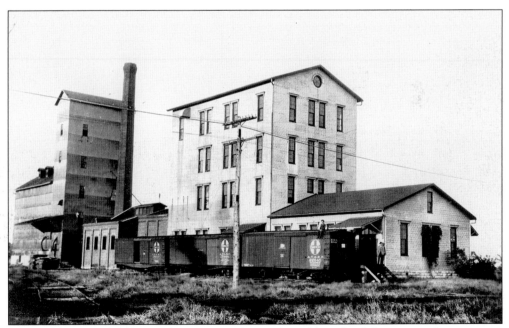

BLACKWELL FLOUR MILL. This commercial structure, although of the most utilitarian type, still shows the application of decorative materials, such as the pressed-tin hood molds over the windows of the main building. It has been in nearly continuous operation since its construction about 1900, and it punctuates the Blackwell skyline to this day.

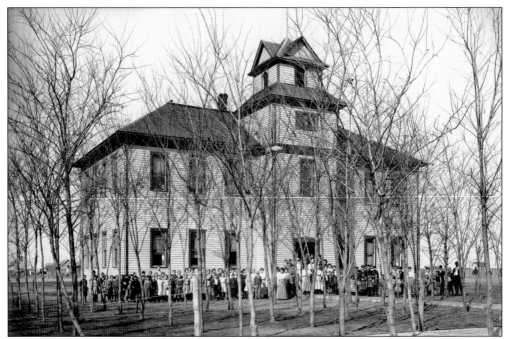

BRAMAN SCHOOL (DEMOLISHED). This wood-frame school served the community for around 15 years. It features a unique gabled bell tower. The small trees are typical of pictures from this time. Many of the Kay County communities were founded along railroad tracks instead of on the banks of rivers and streams, and trees were scarce on the prairies. Early settlers quickly planted them, often in large number. (Courtesy of Jerry Johnston.)

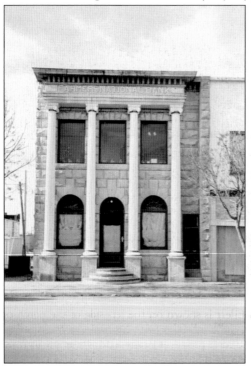

FARMER'S NATIONAL BANK, NEWKIRK. Constructed in 1906 of locally quarried limestone and decorated with full-height iron columns, this building is a marriage of the vernacular and the classical revival. The temple-front design was originally capped with a gable-shaped pediment above the existing cornice, both of pressed metal.

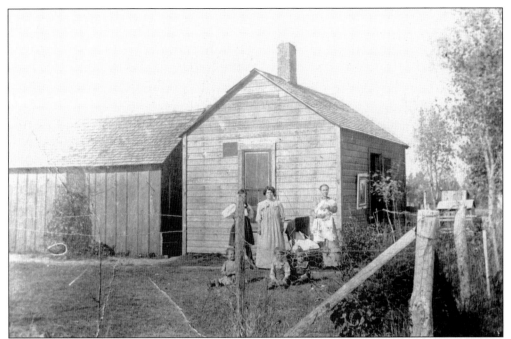

MURPHY HOUSE, NARDIN. Evocative of the second wave of construction on the prairie is the frame house shown here. Of more substantial construction than the soddies and stone cabins erected right after the run, this home is constructed of milled lumber, albeit unpainted. (Courtesy of L. V. Crow, Friends of Nardin.)

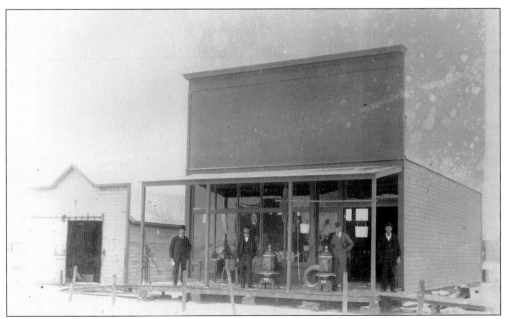

EILERT STORE, NARDIN, (DEMOLISHED). John Eilert is shown on the left side of the porch of his hardware store in this 1898 picture. The unusually tall false front covered the gable end of this store building. The large glass windows would have provided better light, while the awning shaded the inside from the hot summer sun. (Courtesy of L. V. Crow, Friends of Nardin.)

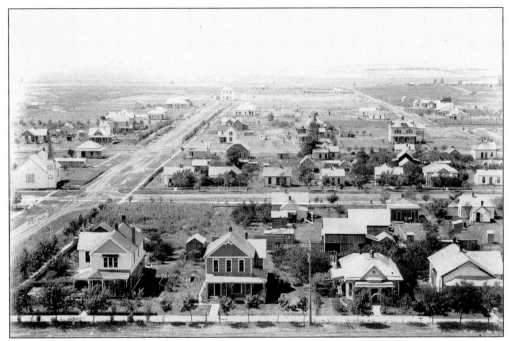

A NEWKIRK NEIGHBORHOOD. Taken at the same time as the downtown aerial view shown on page 22, this view shows the neighborhood directly west of downtown. On the left is the Christian Church on Ninth Street. The front row of houses are those on Maple Avenue, with Walnut and then Magnolia Avenues behind. Many of these fine homes still grace the streets of Newkirk. (Courtesy of Newkirk Main Street.)

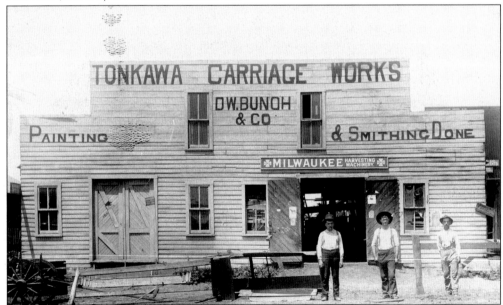

TONKAWA CARRIAGE WORKS. Absolutely essential to success on the farms of Kay County were good blacksmiths, and Tonkawa was served by the D. W. Bunch and Company Carriage Works. This is a rather large false-front building with a second story in the tall attic of the gable roof. (Courtesy of the Tonkawa Historical Society.)

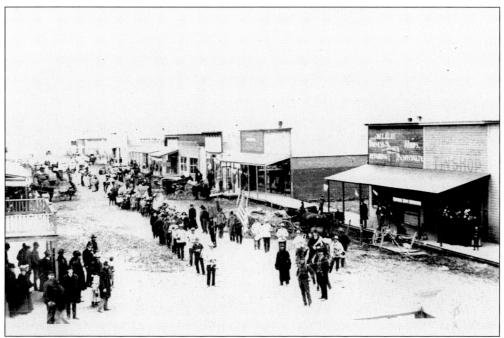

DOWNTOWN NARDIN. Nardin was named for George Nardin, who sold the land on which the city was established in 1898. Within two weeks of its creation, Nardin could proudly boast of having a dozen or so buildings either completed or under construction. In 1900, the town had a hotel, two restaurants, and even a cigar factory. (Courtesy of L. V. Crow, Friends of Nardin.)

ALLEN HOUSE, TONKAWA, C. 1899. The home of E. W. Allen, Tonkawa's first depot agent, is a folk vernacular L-shaped house and features spindles, shingles, and decorative elements on the large porch—all factory-milled. The center chimney would have allowed the use of multiple wood stoves to insure that most rooms of the small home would remain warm during the bitter Oklahoma winter. (Courtesy of the Tonkawa Historical Society.)

STREET SCENE, PONCA CITY (DEMOLISHED). The Citizen's State Bank, Koller, and Hord buildings (left to right), were among the earliest two-story masonry structures in Ponca City. The bank building was of stone. The other two were of brick and featured corbelled parapets with decorative name blocks above. The bank building was demolished in 1924, and the remaining buildings were lost to fire in the 1960s.

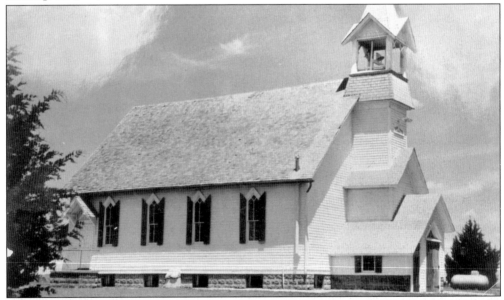

PRAIRIE CHAPEL. This small church was built by George Johnston of Wichita for a fee of $1,800 in the fall of 1898. It is located between Blackwell and Ponca City to serve the rural community. The seats for the church were reused from a theater in Wichita. It was finally electrified in 1940, during the rural electrification efforts that took place during the Depression. (Courtesy of Newkirk Main Street.)

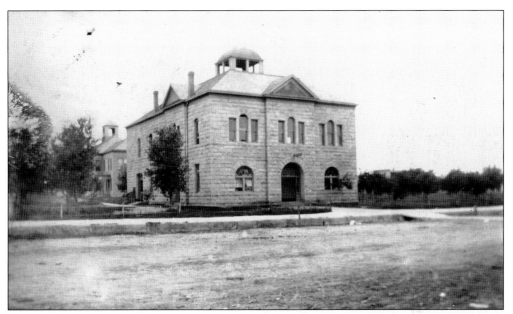

NEWKIRK CITY HALL (ALTERED). In 1900, the community of Newkirk voted a bond issue of $6,000 to construct the new city hall. Nehemiah M. Tubbs was awarded the contract. The building featured a second-floor opera house, and the post office rented a downstairs room for $14 per month. The second floor was removed in 1973. (Courtesy of Newkirk Main Street.)

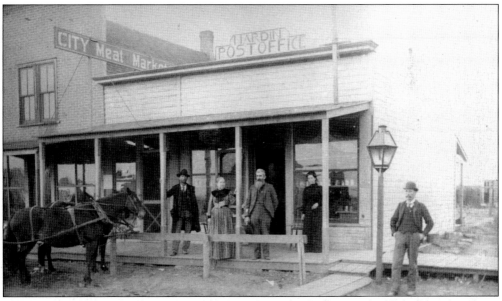

NARDIN POST OFFICE. This interesting picture features a fairly typical early building but shows one of the earliest forms of public street lighting found in Kay County, around 1899. The posts supporting the awning roof in this case did not serve their other function as a place to tie the horses, since this building had a hitching rail. (Courtesy of L. V. Crow, Friends of Nardin.)

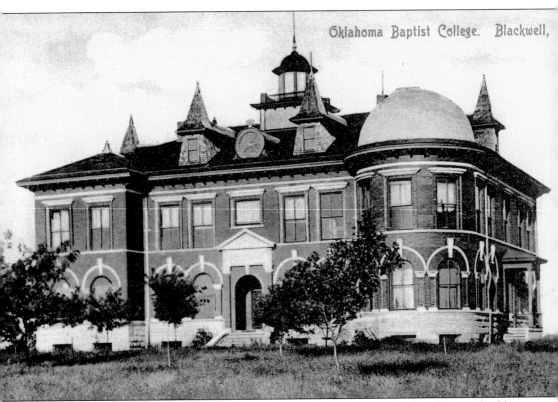

BAPTIST COLLEGE, BLACKWELL (DEMOLISHED). The cornerstone for this elaborate building was laid on October 13, 1900, and the building opened formally in 1904. It served as a preparatory school until 1913, when it was purchased and operated as the Blackwell Osteopathic Hospital. In 1936, it became a grade school, and it was demolished about 1950 after the new Washington School was constructed (see page 12). The eclectic mix of classical, Victorian, and other elements defy categorization of its architectural style, although it could be classified as classical revival. Among its architectural features are an elaborate classical entry and window surrounds, the unique dome, and the many spire-topped dormers. The lower wall up to the bottom of the first-floor windows was of rusticated stone, and a stone belt course surrounded the building at the level of the first floor ceiling. It was called the "West College Castle" by the community.

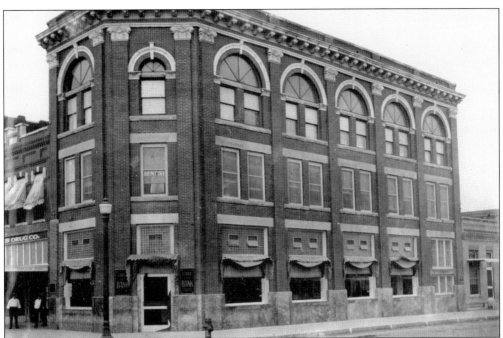

TWO BANKS OF 1900. The Blackwell Masonic building, above, is compared here to the high-Victorian Eastman Bank in Newkirk. The Masonic building is an imposing classical revival–style building, with Corinthian capitals at the top of engaged columns at the corners and an elaborate cornice, probably of pressed tin. This building was demolished in 1966. The Eastman bank, below, was a confection of stone, with one tower composed of a first-floor arched window, above which is a horseshoe arch window, topped by a gabled roof with decorative iron railing atop. The main entry tower begins with an arched opening supported by marble columns, surmounted by a set of windows in another arch, and the whole crowned by a curved mansard roof. This building was altered in 1954 with the removal of the top floors. (Courtesy of Newkirk Main Street, Blackwell Masonic Lodge.)

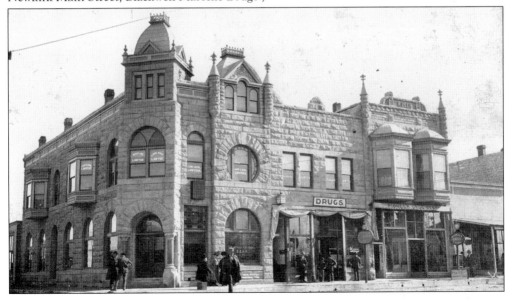

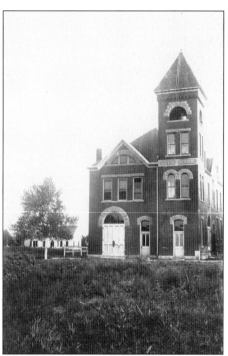

CITY HALL, PONCA CITY (DEMOLISHED). Ponca City's old city hall was constructed in 1900 and featured a four-story bell tower and the generous use of limestone details, including over the arched main-level windows and doors. Constructed of brick by O. F. Keck of the city, the building stood for 14 years on the site of the current civic center complex.

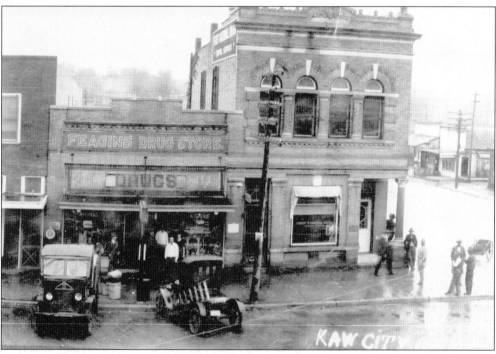

FARMER'S NATIONAL BANK, KAW CITY (DEMOLISHED). This two-story brick building was constructed in 1909 to replace the original wood-frame bank. To insure that the bank could continue to function during construction, the original building was moved out into the middle of Fifth Avenue and remained open until the new building was completed. This building was in use until 1965. (Courtesy of Kaw City Museum.)

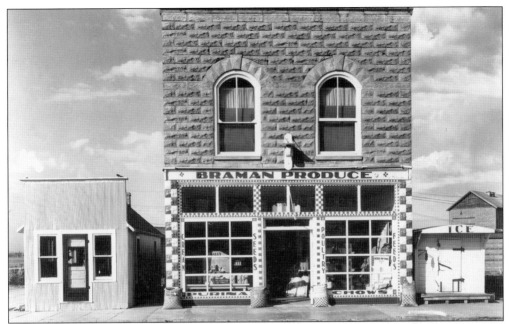

BRAMAN PRODUCE. The Braman Produce building was constructed of concrete blocks, which were cast on site by the workers. Molds could be purchased, a savings over the cost of having concrete blocks shipped. It features large expanses of east-facing glass and very decorative arched windows on the second floor. The Braman Produce building was constructed in 1900. (Courtesy of Jerry Johnston.)

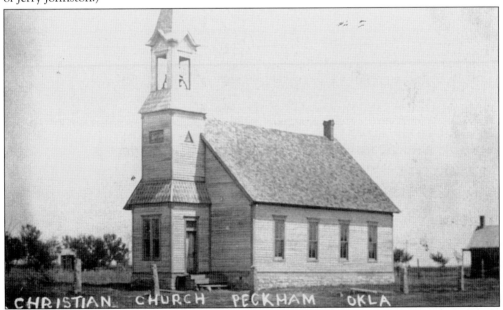

PECKHAM CHRISTIAN CHURCH (ALTERED). The Peckham Christian Church was originally constructed outside of Peckham, and relocated into town in 1902. Moving of buildings at that time was not unusual but was more work than today, requiring many men and horses. The Peckham church featured gas lighting in 1909 and was electrified in the 1940s. (Courtesy of Newkirk Main Street.)

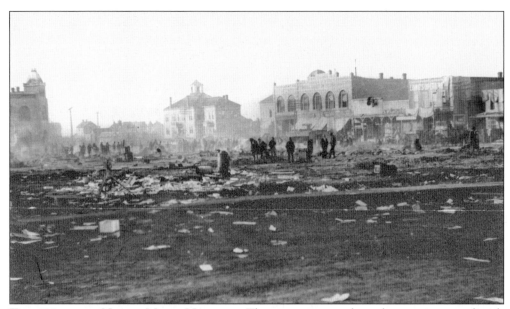

THE 100 BLOCK NORTH MAIN, NEWKIRK. These two images show the amazing speed with which the pioneers built and rebuilt their communities. In 1901, the entire block of buildings was destroyed by fire. But, by 1903, the entire side of the street had been rebuilt in stone and brick. The buildings shown in the lower picture, from right to left, are the Pabst, Black, and Rogers buildings (all from 1902), followed by the Midgely and Hardesty buildings (1903), and the Mason building (1902). The Pabst building is similar to ones built in Ponca City and across the county by the brewery, and has a crenulated cornice and a classically inspired entry. (Courtesy of Newkirk Main Street.)

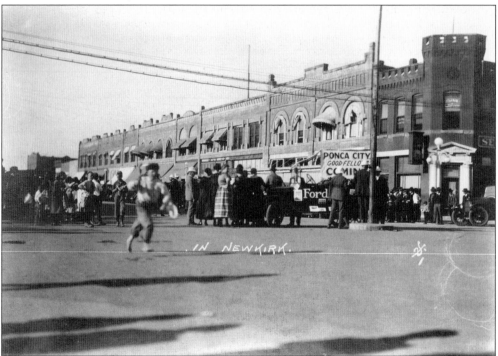

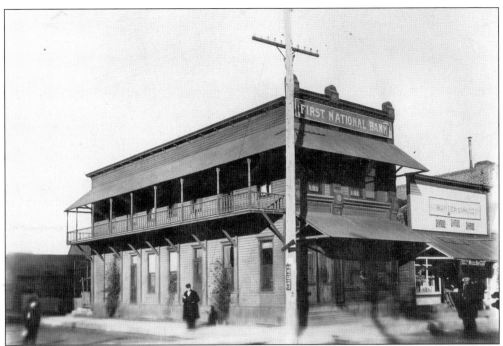

PONCA CITY'S FIRST NATIONAL BANK. The First National Bank of Ponca City was originally in these two buildings and was established by Charles DeRoberts. The one at the top (demolished) was originally constructed in Cross and was moved to the corner of First Street and Grand Avenue in Ponca City during the late 1880s. With a balcony extending from front to back on the west side, it was unique in the community. The metal frame of this building became the frame for the DeRoberts/Calkins residence when this building was replaced with the one below in 1905. The new building was built of high-fired hard brick and was enhanced by its classically inspired pressed-tin cornice. It is still standing today. (Above, courtesy of Marland's Grand Home.)

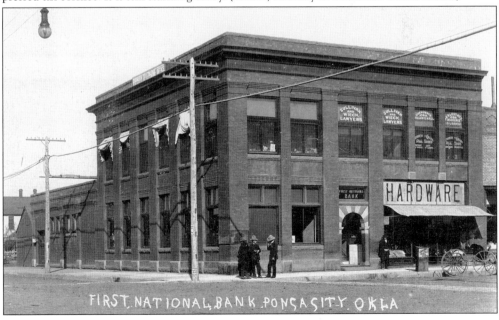

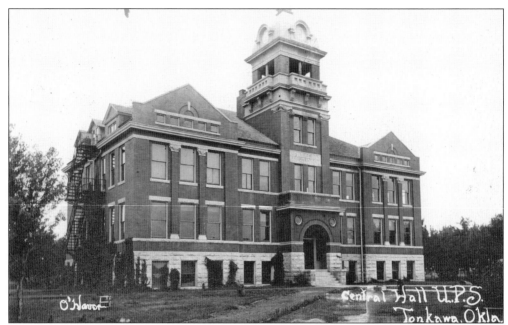

CENTRAL HALL, UNIVERSITY PREPARATORY SCHOOL, TONKAWA. O. F. Keck of Ponca City constructed this building for the University Preparatory School of red brick accented with limestone. The tower is similar to the one found on the Blackwell City Hall building, with balconets supported by brackets and a mansard-style dome with arch-top blind windows. The basement level has rusticated limestone, and capitals top the full-height engaged columns between the windows. Central Hall was constructed in 1902.

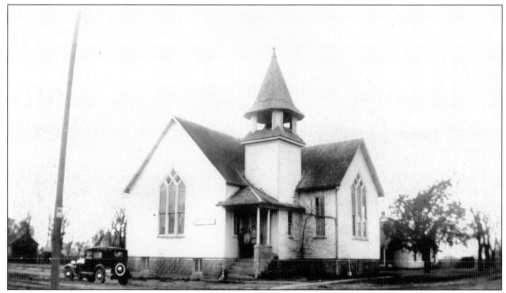

NARDIN UNITED METHODIST CHURCH, C. 1899. The congregation borrowed the large sum of $200 (at six percent interest) to build this Gothic-inspired wood building, and Martha Robertson donated another $50 that she borrowed herself. After completion, the congregation owed a total of $1,100 plus $90 for the organ—debts they quickly paid off. (Courtesy of L. V. Crow, Friends of Nardin.)

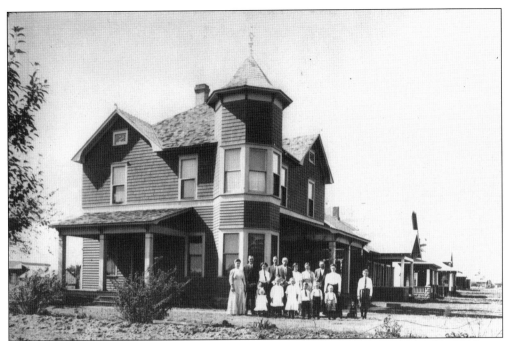

WILLIAM TAYLOR HOUSE, TONKAWA. This late-Victorian house was one of a kind in Tonkawa, featuring an octagonal tower and large east side porch. East porches were favored in the early days because they provided a shaded evening sitting place. The finial on the tower roof is a show of prosperity, since its only function was decoration. (Courtesy of the Tonkawa Historical Society.)

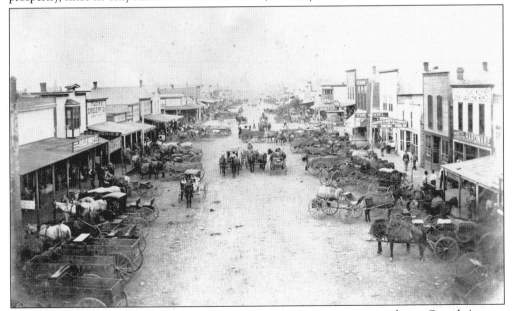

EARLY DOWNTOWN PONCA CITY. This busy Ponca City street scene shows Grand Avenue before 1900, when most of the buildings were still of wood. The elevated view was possible only because there was a water tower near the intersection of First Street and Grand Avenue, from which the photograph was taken. At this time, Newkirk and Blackwell both already had many fine buildings of brick and stone.

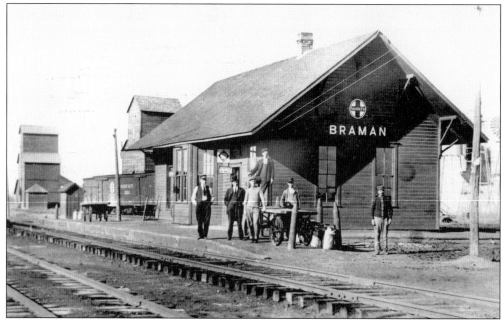

BRAMAN DEPOT. The Braman Santa Fe Depot was not unusual for a small Oklahoma town of the early 20th century. As was common along the railroads, grain elevators are located nearby. Depots at this time were the prairie town's only link to the rest of the world and brought news, people, food, and building materials to the growing communities. (Courtesy of Jerry Johnston.)

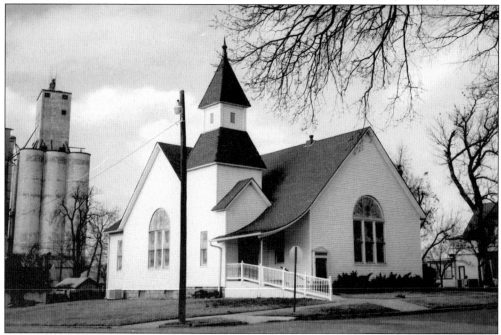

TONKAWA PRESBYTERIAN CHURCH. One of only a few remaining early-20th-century side-steeple churches in Kay County, this wonderful building features windows obtained by builder J. M. Schwab from a church on the East Coast. The church was dedicated on June 5, 1905, and is listed on the National Register of Historic Places.

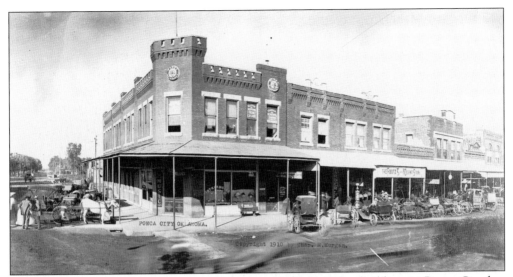

PONCA CITY PABST BUILDING. Constructed in 1902, the Pabst building in Ponca City has the crenulated parapet supported by corbels at the top and limestone head molds and sills for the upstairs windows used on many of the Pabst buildings of that time. The Pabst logo was a predominant feature of the angled entry wall and adorned the building until the late 20th century. The Rose Saloon, inside, was one of the finest of the many saloons in Ponca City, with a wallpapered ceiling (complete with Pabst logo) and elaborate front and back bars. Cigars, a natural part of the saloon experience, were also sold at this establishment. The saloons of Ponca City, as well as all the others in Kay County, were closed when Oklahoma became a state.

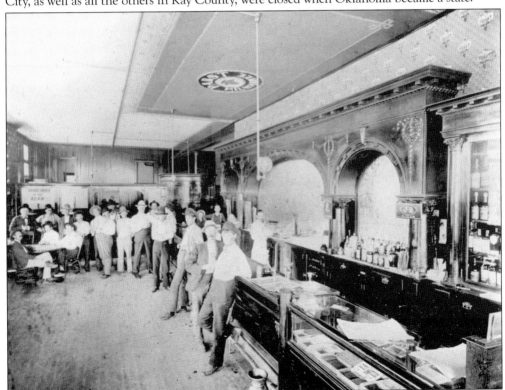

BEN BRALY RESIDENCE, NARDIN. The Bralys of Nardin, successful in business, owned this folk-vernacular home complete with mail-order millwork on the porch columns. The shallow pyramidal roof and center chimney were common features of small homes of this time, although the railing around the top was not. Also marking this as a home of a relatively affluent citizen was the ornamental fence. (Courtesy of L. V. Crow, Friends of Nardin.)

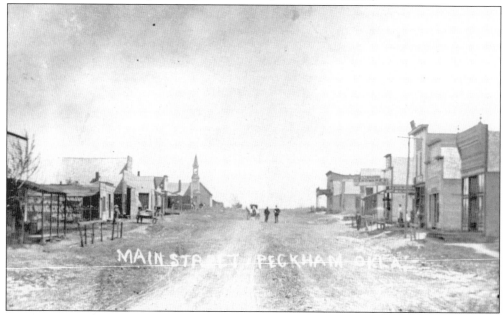

DOWNTOWN PECKHAM. Peckham, like Braman, was platted a few years after the land run, after the Frisco route was established in 1899 connecting Arkansas City, Kansas, to Enid, Oklahoma. Once the population of the town numbered 400, and had thriving stores and lumberyards, as well as a hotel and candy store. (Courtesy of Karen Dye.)

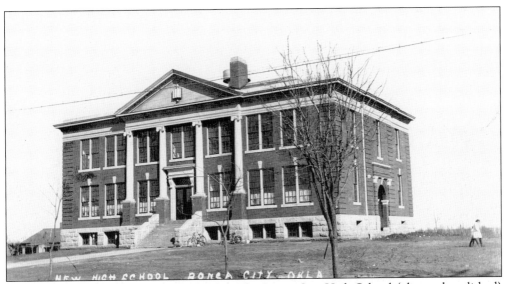

ARCHITECT SOLOMON ANDREW LAYTON. The Ponca City High School (above, demolished) and Wilkin Hall (below) at the University Preparatory School in Tonkawa were both designed by noted architect Solomon Andrew Layton and constructed in 1905. The classical revival high school was built using proceeds of an $18,000 bond issue. It featured four full-height engaged Ionic capitals supporting the pediment with a center medallion of an open book. The basement was of rusticated stone, and the flat-arch window tops of the first floor had granite keystones. The most notable feature of Wilkin Hall was its original dome, lost and not replaced after a devastating fire in 1914. Wilkin also has Ionic columns supporting the entry porch and has brick laid in coursed layers to distinguish the basement level.

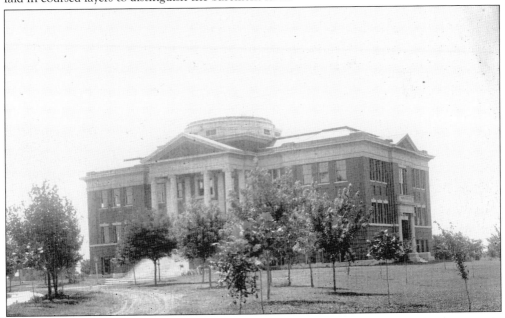

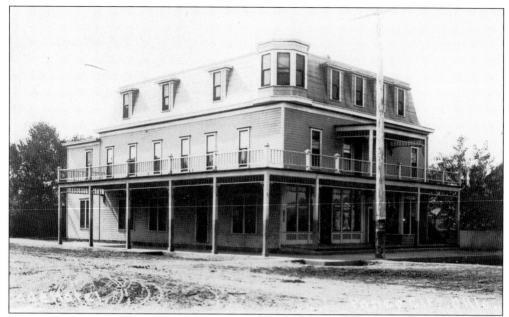

ARCADE HOTEL, PONCA CITY (DEMOLISHED). The Arcade Hotel, like the First National Bank building, was originally constructed in Cross and moved to Ponca. In 1905, the original two-story building gained a mansard roof with dormers providing a third story of rooms, as well as a corner tower. Compare this to the 1916 version on page 66.

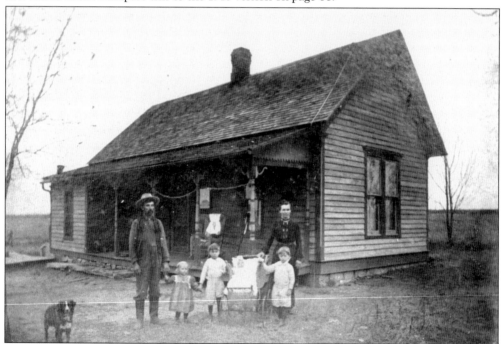

FOLK-VERNACULAR IN NEWKIRK. This example of the early folk-vernacular house is the end-gable configuration and makes use of a nearly full-length porch on the front. The house is only one room deep, and probably heated by only one stove located in the kitchen, an awfully tight squeeze for the family of six shown in the picture! (Courtesy of Newkirk Main Street.)

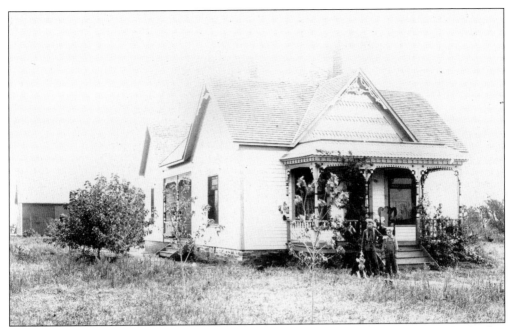

GREGORY HOUSE, TONKAWA. The Wiley William Gregory house in Tonkawa shows that machine-made shingles (in the gable ends) and ornamental bargeboards and porch trim were available to the builder, indicating both disposable income and access to mail-order materials. (Courtesy of the Tonkawa Historical Society.)

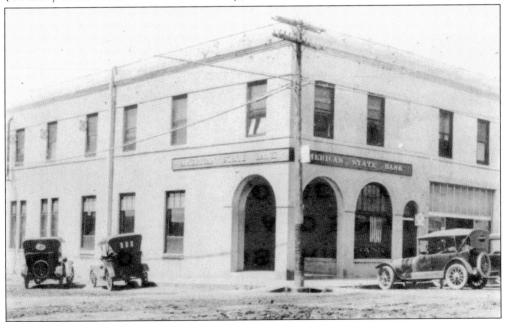

AMERICAN STATE BANK, TONKAWA. Although the date of construction is unknown, this fine and unusual building dates from the very early 1900s. It is unique for its use of stucco instead of the preferred brick or stone, and has equally unique arched entries. These features make it appear to be either an early or inexpensive example of the Spanish mission revival style. (Courtesy of Tonkawa Historical Society.)

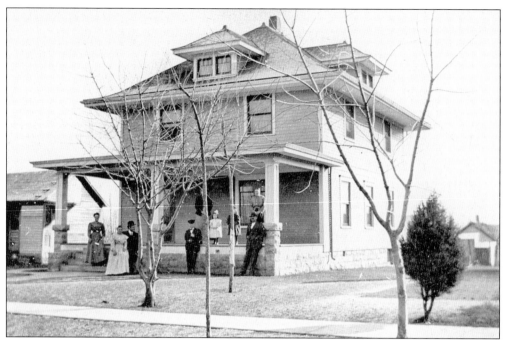

JAMES SHORNDEN HOUSE, PONCA CITY (ALTERED). The Shornden house in Ponca City is a full-blown early-20th-century foursquare house, displaying the fashionable deep eaves, belt course separating the two floors, and simple squared columns supporting the flat roof. Contrary to popular opinion, these large, livable homes were rarely painted white but could sport any earth-tone color or combination of colors. James Shornden was an early business leader in Ponca City.

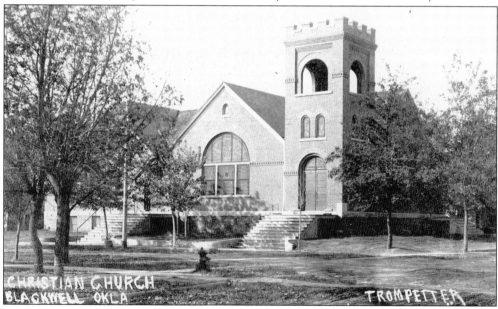

CHRISTIAN CHURCH, BLACKWELL. This 1905 Romanesque Revival church at the corner of McKinley Avenue and First Street is the oldest church still in use in Blackwell. With its crenulated tower, decorative brickwork, and massive stained-glass windows, it exemplifies the early-20th-century brick church in Kay County.

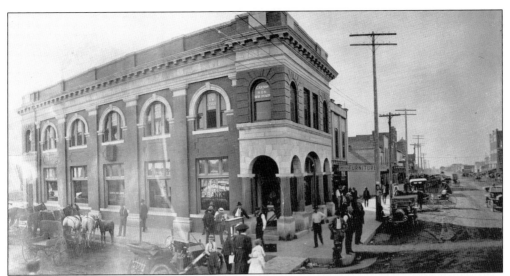

SOLOMON ANDREW LAYTON IN PONCA CITY. These two buildings by Solomon Andrew Layton were constructed between 1907 and 1909. The Farmer's National Bank (altered) above was built in the classical revival style by local builder O. F. Keck. It features short marble columns, elaborate stonework of granite, and a tall bracketed cornice below its solid brick parapet. The Carnegie Library (demolished) below was constructed of white stone and red street brick in 1909, and was 48 feet by 50 feet in dimension, with a 13-foot ceiling. It has an elaborate entry of stone, with "Carnegie" proudly carved above the door, a requirement of Andrew Carnegie. The library once stood at the southwest corner of Fifth Street and Grand Avenue.

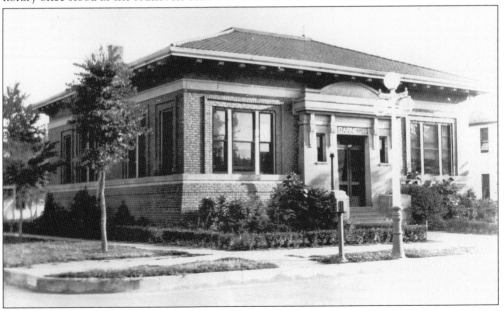

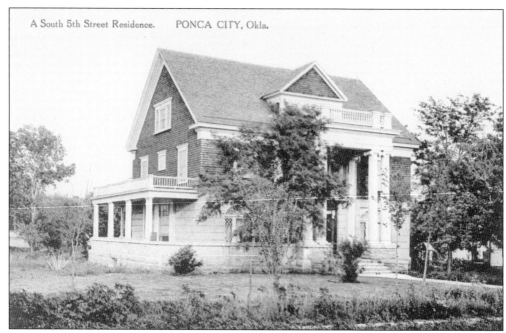

A South 5th Street Residence. PONCA CITY, Okla.

PONCA CITY'S EARLY MANSIONS. The George Brett mansion (above, demolished), the D. J. Donahoe mansion, and the James J. McGraw mansion (below) were all constructed around 1910 in Ponca City by architect Solomon Andrew Layton. The Brett mansion, in the spirit of a southern mansion, exhibits full-height classical Ionic columns supporting the porch, granite walls for the basement and first floor, and two front windows with wonderful tracery. The second and third floors were shingled. The McGraw mansion showed another side of Layton, with solid brick piers terminating with urns supporting the porch, deep eaves supported by brackets, and exposed rafter ends on the porch, all evocative of the prairie style. The Brett mansion was demolished in 1974, but the McGraw and Donahoe mansions remain. The Donahoe mansion is listed on the National Register of Historic Places.

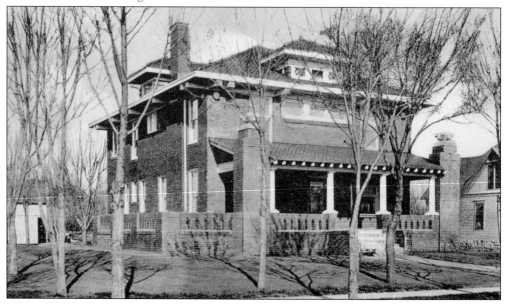

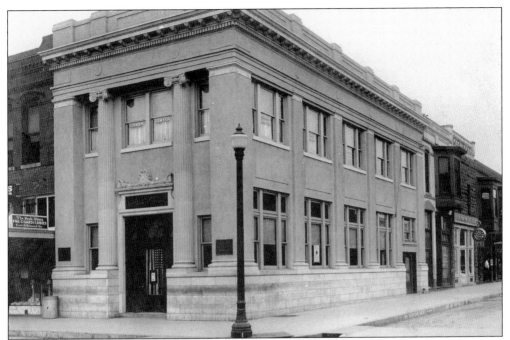

OKLAHOMA GUARANTY BANK, BLACKWELL (ALTERED). With the construction of the Oklahoma Guaranty Bank of Blackwell, the residents of the county had a nearly textbook example of the classical revival style to enjoy. Full-height Ionic columns sprung from its granite base to support a deep cornice and parapet. The cornice was supported by scrolled brackets, and classical decoration topped the entry door. (Courtesy of Top of Oklahoma Historical Society.)

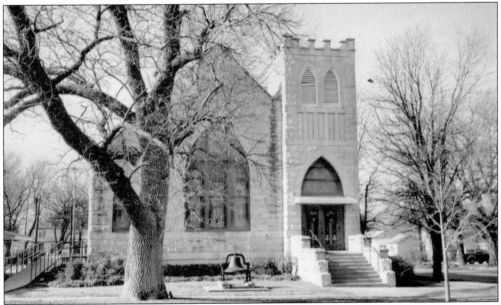

FIRST PRESBYTERIAN CHURCH, NEWKIRK. Constructed in the Gothic Revival style, this church of native stone also features a parapet with battlements on the tower and lancet-shaped windows. The tower is further ornamented with louvered lancet arches at the top. The church was dedicated on January 8, 1911.

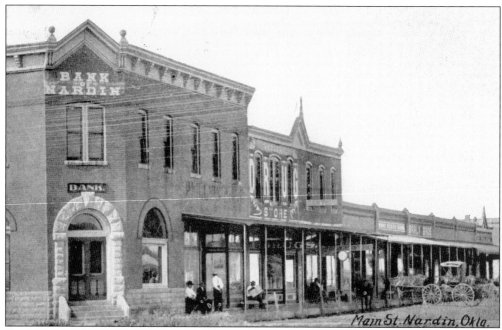

DOWNTOWN NARDIN. Nardin in 1905 had evolved from a collection of wood buildings to a town with fine brick buildings lining at least one side of its Main Street. The Bank of Nardin featured a granite arched entry door and fine pressed-tin cornice. Behind it were two more two-story buildings (Huttington's Drug Store and the Short Order house) and then the one-story buildings housing the Home State Bank and Braly's Hardware store. This entire block of brick buildings was constructed between 1900 and 1905. None of them remain today. (Courtesy of L. V. Crow, Friends of Nardin.)

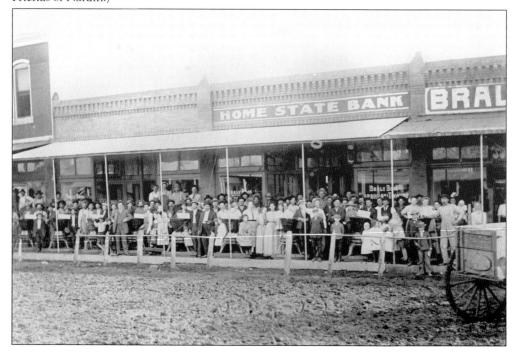

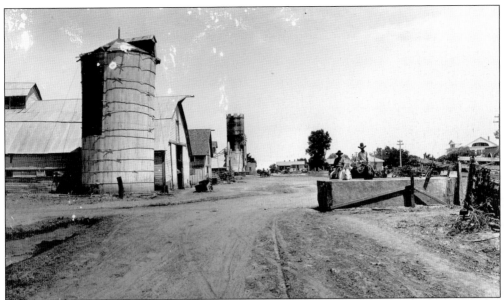

THE 101 RANCH (DEMOLISHED). The 101 Ranch, established by Col. George Miller before the land run of 1893, grew by the early 20th century into one of the largest diversified ranches in the county. Intended by the Miller brothers, George's sons, to be a self-sufficient operation, it had its own meat packing plant, leather and harness shop, electric plant and refinery, and machine shop, among other things. The full scope of the operation can be somewhat understood by the top image. The "White House" is barely visible at top right. Below is the famous White House, which was built after the original home was destroyed by fire in 1909. With full-height Ionic columns, a two-story main porch, and another under the eaves, it was a dignified building. As a nod to the age of the automobile, a porte cochere was attached to the full wraparound porch on the east side. Visible on the left is a garden arcade. The site of the 101 Ranch is on the National Register of Historic Places as a national historic landmark. (Courtesy of Marland's Grand Home.)

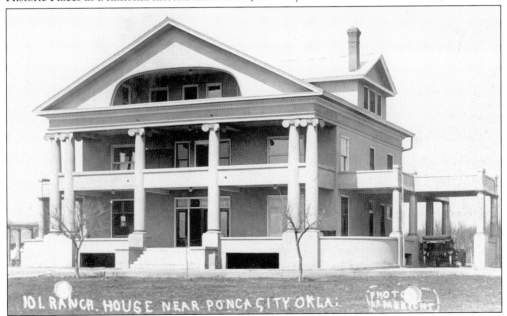

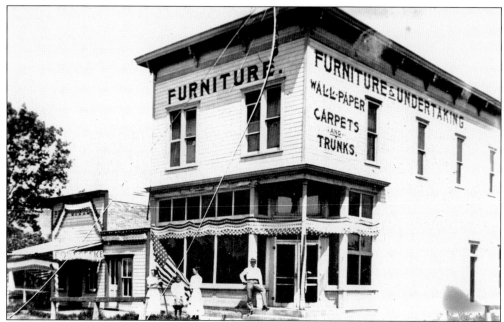

PISHNY FURNITURE. This two-story wood building in Nardin housed both a funeral home (in the rear of the main floor) and a furniture store, a common combination in the late 19th and early 20th centuries. The building shows classical influences such as the deep bracketed cornice, and the broad tall windows would have provided much light in the days before electricity. (Courtesy of L. V. Crow, Friends of Nardin.)

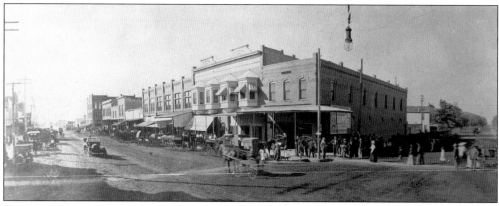

THE 100 BLOCK EAST GRAND, PONCA CITY. This view of the north side of Grand Avenue's 100 block is visually anchored by the Donahoe and Souligny building and its bay windows. The Donahoes and Soulignys were both pioneer families who had experienced success as businessmen in the new Kay County. The Donahoe and Souligny building, constructed in 1909, is one of the few examples of the Italianate Revival in Kay County.

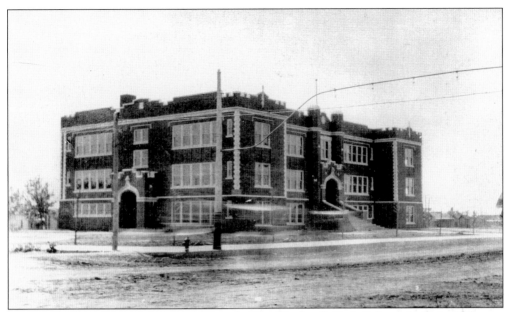

BLACKWELL HIGH SCHOOL (DEMOLISHED). The Blackwell High School, built in 1911, was an example of the Gothic Revival as applied to educational buildings. It has a shaped parapet, corner quoins of limestone, and castlelike entries with Gothic accolades over the doors on each facade. The building served as a high school until 1938. (Courtesy of the Top of Oklahoma Historical Society.)

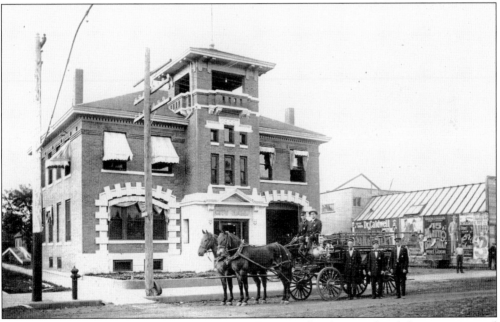

BLACKWELL CITY HALL. The two-story Blackwell City Hall is decorated with limestone around the shallow arches of the first-floor windows, a heavy limestone entry surround, and a unique tower with wide overhanging eaves and a shallow pyramidal roof. It was designed by G. E. Hines of Kansas City and cost $7,000 to build in 1909. (Courtesy of the Top of Oklahoma Historical Society.)

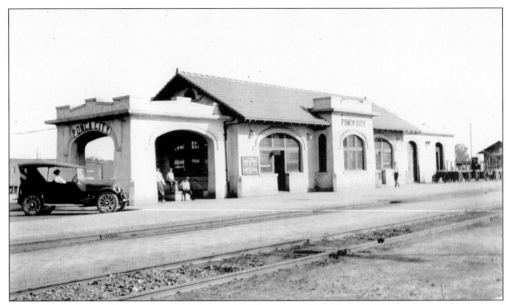

SANTA FE DEPOT, PONCA CITY (ALTERED). The Ponca City Santa Fe Depot was constructed in 1916 at a cost of $22,000. In the Spanish mission revival style, the depot had a shaped parapet and arched openings. The style was perfect for the Santa Fe Railroad, which was beginning to market its line as a route for tourists to America's southwest.

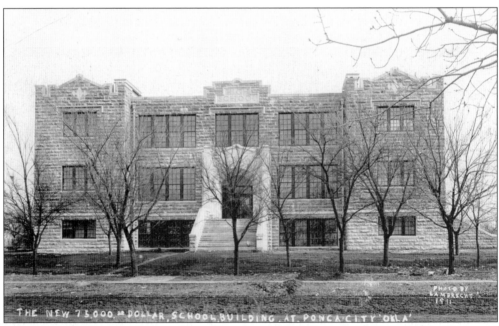

SECOND HIGH SCHOOL, PONCA CITY (DEMOLISHED). Following the 1911 fire that destroyed Ponca City's original stone school, this new school was constructed on the same site. It was built using rough local limestone. It served as Ponca City's high school until the new school was built in 1927 and continued to serve the community as a junior high school until demolished in 1938.

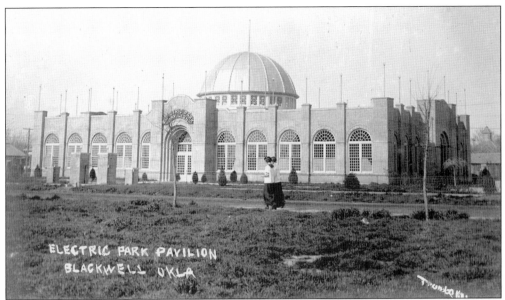

ELECTRIC PARK PAVILION, BLACKWELL. Blackwell's Electric Park Pavilion was designed by W. L. McAltee and made good use of a new utility—electricity. With over 500 lights surrounding the 22 arched windows, lining the ribs of the dome, and topping the 27 flagpoles on each of the exterior piers, it was a spectacular building when viewed at night when its brightness was a sharp counterpoint to the dark prairie nights. U.S. flags flew from each of the flagpoles around the building and from the larger flagpole on the dome. The Beaux-Arts building was formally opened Easter Sunday in 1913, and the opening featured the exuberant music of Handel's *Messiah*. The Electric Park Pavilion is listed on the National Register of Historic Places.

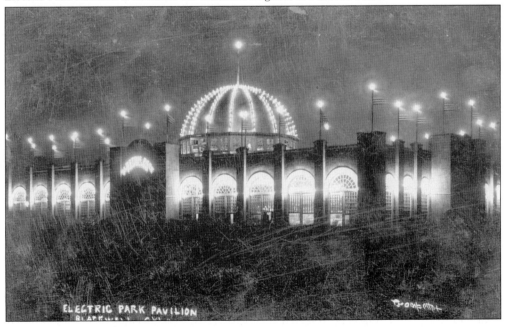

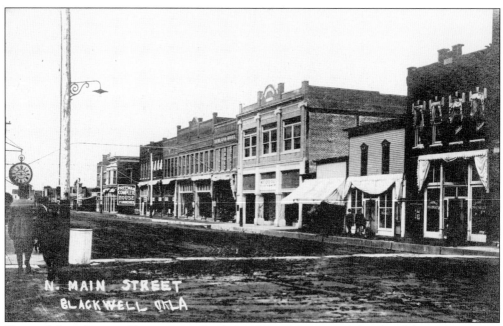

NORTH MAIN STREET, BLACKWELL. By the middle of the second decade of the 20th century, Blackwell's Main Street was composed of mostly brick buildings, but a few wood-frame buildings from the early days remained. The light-brick building in the center, with classical influences in the columns, was home for West Dyers until it moved to the newer building shown on page 95.

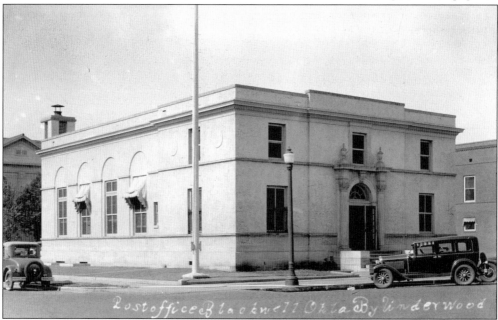

BLACKWELL POST OFFICE (ALTERED). The classical revival influences are strong in this small building featuring Corinthian columns surmounted by classical urns on each side of the entry door, windows in blind arches on the sides, and dentil moldings below the shallow cornice. The second floor of this building served as a federal courthouse when the building was constructed in 1915. (Courtesy of the Top of Oklahoma Historical Society.)

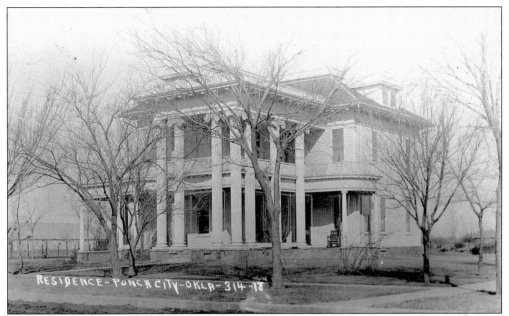

DeRoberts and Calkins Residence, Ponca City (Altered). C. N. Terry of Wichita was the architect for this 9,000-square-foot residence, which was the largest in Ponca City until the construction of the Marland Mansion in 1928. The home was originally built around 1907, using the metal frame of Charles DeRobert's old bank building (see page 37), but remodeled and turned on the lot following the 1912 tornado.

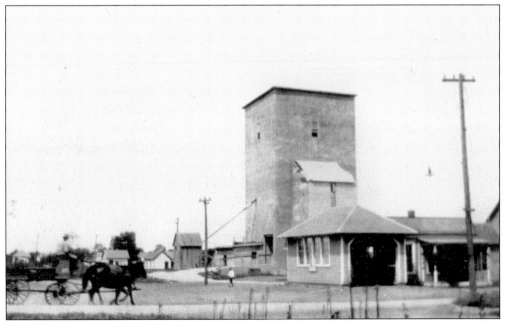

Shornden Grain Elevator, Ponca City. In 1912, James Shornden built this grain elevator, his second. This was one of the earliest poured-concrete elevators in Oklahoma. The Shornden businesses also included a nearby gas station as the automobile became more popular. The elevator still stands north of downtown Ponca City.

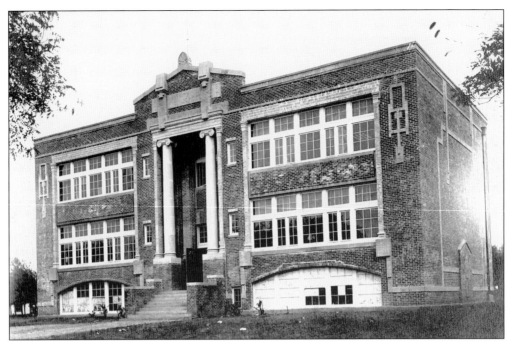

BRAMAN HIGH SCHOOL (DEMOLISHED). This school is decorated with oversized details, relieved by the large expanses of glass and the wide arched openings that provide light to the basement. The building, constructed in 1915, was condemned in the 1930s. It is said that after removing one wall during demolition, the concrete second floor refused to fall, casting doubt on the decision that it was not structurally sound. (Courtesy of Jerry Johnston.)

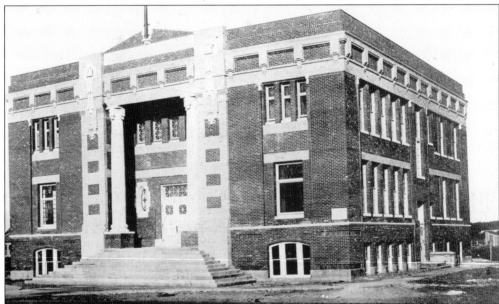

GRADED SCHOOL, KAW CITY (DEMOLISHED). Similar in massing to the Braman school shown above, the Kaw City school was designed by VanMeter and Schmitt of Oklahoma City, constructed in 1910, and cost the community $15,000. It stood predominantly on a small hill overlooking downtown until its demolition when Kaw Lake was being completed. (Courtesy of the Kaw City Museum.)

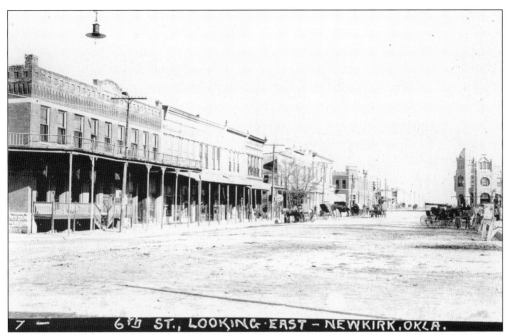

STREET SCENE, NEWKIRK. Looking east toward downtown on Sixth Street in Newkirk, one is greeted by almost this same scene today, other than the removal of the shed awnings over the entries and the balcony of the Park Hotel. These buildings are all included in the Newkirk National Register Historic District. (Courtesy of Newkirk Main Street.)

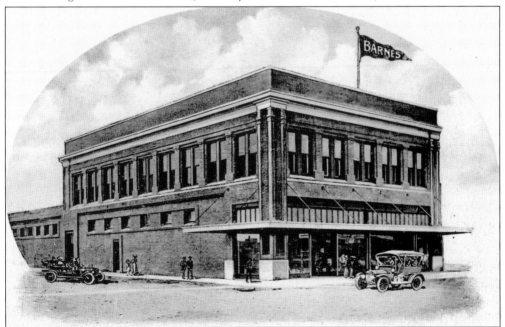

BARNES STORE, PONCA CITY, C. 1911. Attributed to Solomon Andrew Layton and constructed by the Welch family of masons, the Barnes store (constructed 1911) is a good example of the early commercial style of architecture. It features a strong cornice and massive piers at each end. The design was so good that another merchant built a similar building next door within five years.

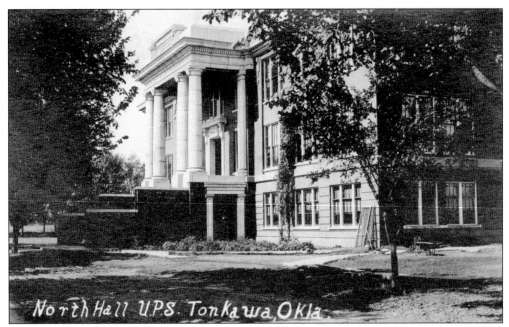

NORTH HALL, UNIVERSITY PREPARATORY SCHOOL, TONKAWA. This classical revival building is built across the oval from the early Wilkin Hall (shown on page 43) and is similar in design. It has Doric columns decorated with an open book at each capital, and the basement walls are enlivened by recessing one course of bricks for every five or six. (Courtesy of the Tonkawa Historical Society.)

JONES RESIDENCE, NARDIN. Another of the folk Victorian homes of the early 20th century, the home of Mr. and Mrs. Francis M. Jones had a sunny porch with columns painted in multiple colors, as was the trend of the day. With multiple flues, this home would have featured both kitchen and parlor stoves. (Courtesy of L. V. Crow, Friends of Nardin.)

Two

Oil and Prosperity
Buildings from 1916 to 1929

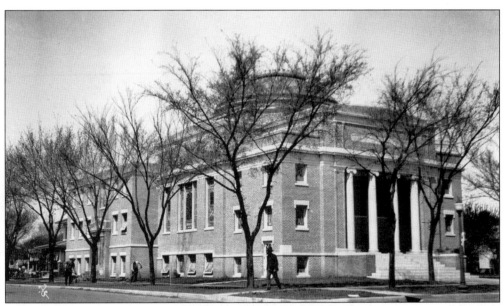

First Presbyterian Church, Ponca City (Demolished). The congregation of the First Presbyterian Church decided to build a new church on July 10, 1920. They demolished the earlier building and began work on this classical revival church. Featuring a stone belt course and window surrounds, Ionic columns, and a glass dome, it was one of the most spectacular churches in the county. The church was designed by Butler and Saunders of Tulsa and constructed by J. C. Ibach of Ponca City.

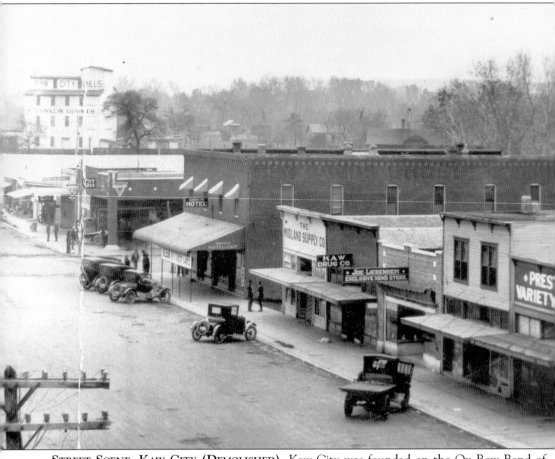

STREET SCENE, KAW CITY (DEMOLISHED). Kaw City was founded on the Ox Bow Bend of the Arkansas River by the Kaw City Townsite Company. The developers were N. F. Frazier, C. W. Carey, W. E. Brown, and William Jenkins. Jenkins was the fifth governor of the Oklahoma Territory. Lots were first offered for sale on the Fourth of July, 1902. The Conklin Grain Company overlooks downtown in this picture from the late 1920s. This part of downtown was still primarily wood-frame buildings, other than the hotel and Marland Oil service station on two corners. Kaw City began to decline in the 1920s following a devastating flood and was finally abandoned as Kaw Lake was constructed in the late 1960s and early 1970s. Several of the original buildings were relocated to a new Kaw City on a hill overlooking the lake, including the original train depot. The depot serves today as a museum of Kaw City history. (Courtesy of the Kaw City Museum.)

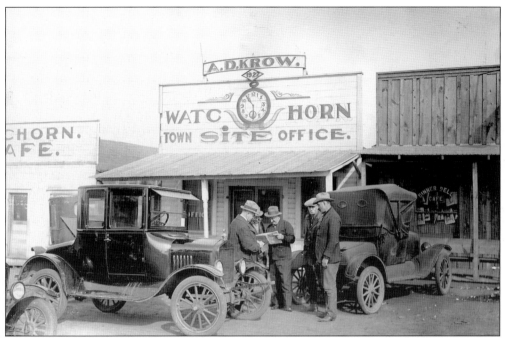

WATCHORN TOWNSITE OFFICE (DEMOLISHED). Watchorn, southwest of Tonkawa, was another oil-boom town that failed to catch hold, although the population included many of the men who worked the oil fields of southwest Kay County. This false-front building, which would be more at home in the late 1890s, is more ornamental than many seen in that earlier time. (Courtesy of Marland's Grand Home.)

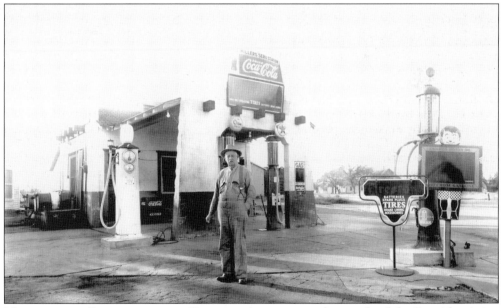

MISSION-STYLE SERVICE STATION, BRAMAN. A very unusual example of the Spanish mission revival style is this service station. While the style was quite popular for residences and commercial buildings, it is unusual to see the style used for this type of building. This small building is still true to the style and includes vigas and battered walls. (Courtesy of Jerry Johnston.)

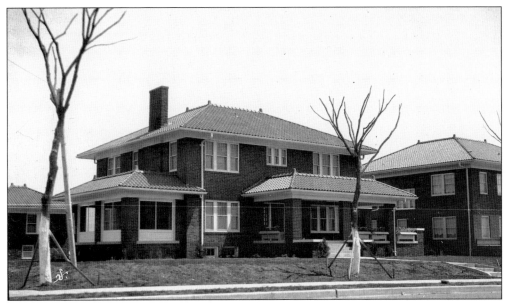

MARTIN HOUSE, PONCA CITY. This home was built in the 1920s for Charles Martin and his wife, Marie. Charles was a vice president for Marland Oil Company. After his death, Marie married Col. T. D. Harris of Continental Oil Company. Marie was one of the hostesses when the Marland Mansion was opened, and attended the inauguration of Pres. Franklin D. Roosevelt. The brick home, with a red tile roof, is a south Ponca City landmark.

PONCA CITY AMERICAN LEGION BUILDING (DEMOLISHED). In 1919, E. W. Marland had plans prepared for an office complex, which included a new office building, shopping district, and an entire neighborhood. This building was constructed originally as housing for single male employees in the neighborhood district. Solomon Andrew Layton was the architect for the office building, page 74, as well as most of the first homes in what is now the Marland Addition.

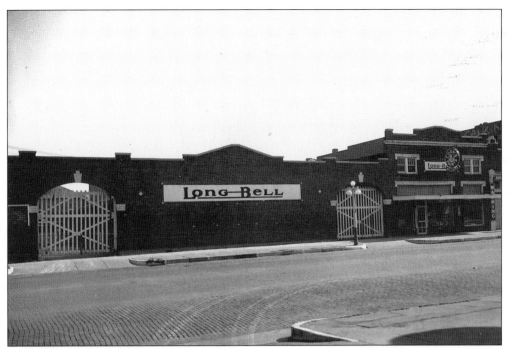

LONG-BELL LUMBER YARD (DEMOLISHED). This business was located at the west end of Ponca City's Grand Avenue, near the railroad tracks. In the early commercial style, the red brick building is accented with stone details. The building burned in the late 1960s.

SUPREME SERVICE STATION, PONCA CITY (DEMOLISHED). While other companies were building cottage-type gas stations, the Supreme gas station on South Pine Street was constructed in a more modern style. The building cost $7,500 when built in 1919. In this image, an employee is shown wearing a white uniform jacket, and gas was only 22¢ per gallon.

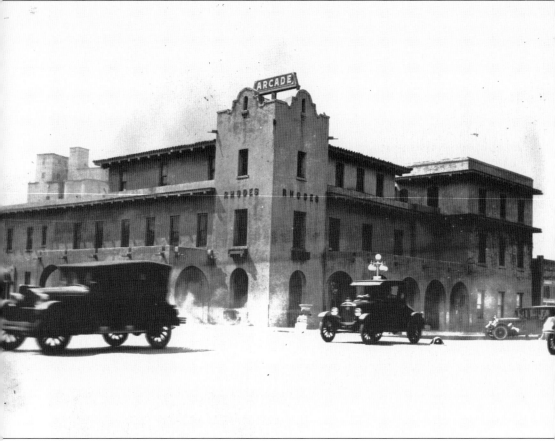

ARCADE HOTEL, PONCA CITY (DEMOLISHED). This hotel was moved to Ponca City from Cross late in the 19th century, after Ponca City received a stop on the Santa Fe Railroad. The Arcade was renovated several times before the final renovation in 1916 changed the appearance to full Spanish mission revival style. The style was quite popular in Ponca City, both before and after the Arcade was completed. The renovation cost over $100,000, and the architect for the renovation is thought to have been Solomon Andrew Layton. It was completely stuccoed and featured arcades on both the north and east sides. The design was entirely compatible with the Civic Center Auditorium at the other end of Grand Avenue, completed at about the same time (page 68). It was considered to be the finest hotel in northern Oklahoma, and guests of the hotel included Presidents William Howard Taft and Theodore Roosevelt, Will Rogers, Wiley Post, Jack Dempsey, Ty Cobb, and William Jennings Bryan. It was demolished in 1974.

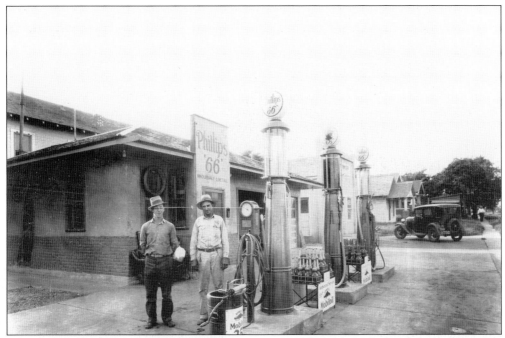

PHILLIPS SERVICE STATION, BLACKWELL. Gas stations of the early 20th century were a lucrative enterprise, and the newly motoring public expected full service. This Phillips 66 station is a brick and stucco building with two automobile bays. The gravity-feed pumps are an indication of its age. (Courtesy of the Top of Oklahoma Historical Society.)

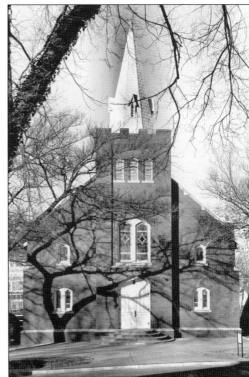

ST. MARY'S CATHOLIC CHURCH (DEMOLISHED). Another building attributed to the prolific firm of Solomon Andrew Layton is the St. Mary's Catholic Church of Ponca City. The dark red brick church with an octagonal steeple replaced an earlier church, which had burned. It was completed at a cost of over $20,000 in 1916. (Courtesy of First Baptist Church of Ponca City.)

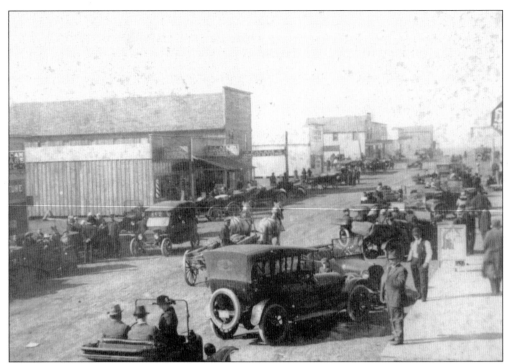

DOWNTOWN DILLWORTH. Dillworth was established following the discovery of the Dillworth field in 1911, and this view of downtown could have been taken in another town 10 years earlier, other than the appearance of automobiles. Dillworth was granted a post office in 1917, but the downtown was destroyed by fire in 1926 and the town disappeared. (Courtesy of Karen Dye.)

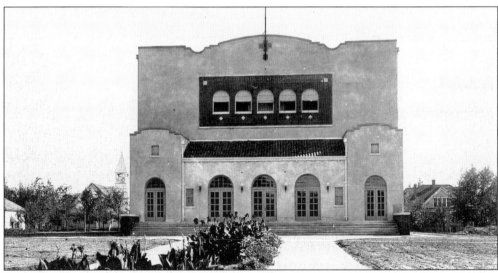

CIVIC CENTER AUDITORIUM, PONCA CITY. Solomon Andrew Layton designed this building at about the same time he was designing the Oklahoma State Capitol. The Spanish mission revival–style building was used for all nature of entertainments, but its first use was to send 141 Kay County boys off to World War I in 1917. Performers who appeared here included Will Rogers, Duke Ellington, Sally Rand, and John Phillip Sousa.

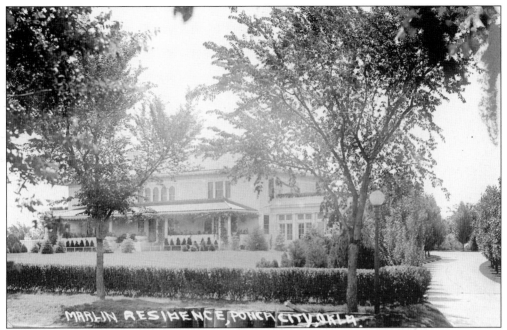

MARLIN RESIDENCE, PONCA CITY, OKLA.

MARLAND RESIDENCE, PONCA CITY. In 1916, five years after his first successful well in Oklahoma, E. W. Marland built this home on East Grand Avenue. Designed by the firm of Solomon Andrew Layton and constructed by local contract O. F. Keck, the 22-room Mediterranean-style mansion boasted one of the first indoor swimming pools in Oklahoma, a central vacuum system, and a three-car garage. The home was set at the southwest corner of 80 acres of landscaped gardens, which included a nine-hole golf course. The nine-hole golf course was open to any residents. The grounds stretched for a length of three city blocks, terminated on the east by the greenhouse shown below. The Marland residence is listed in the National Register of Historic Places.

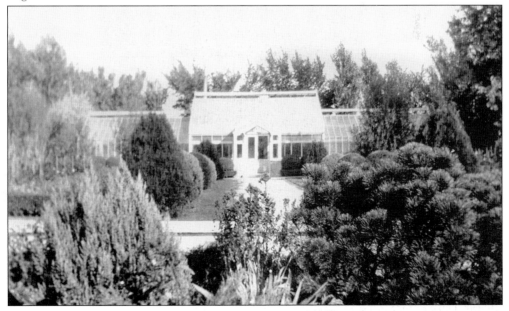

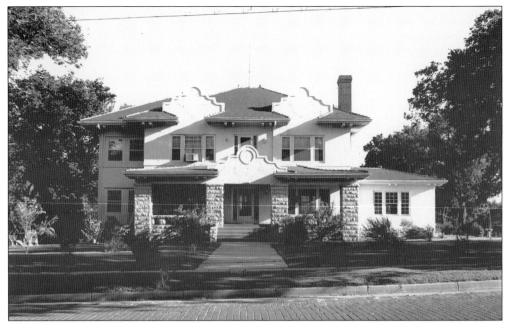

HENRY BUCKNER RESIDENCE, PONCA CITY. Along the south side of Central Avenue, across from the Marland Residence, three large homes were constructed facing the Marland gardens. One of these is the Buckner home, built in 1918 for Henry Buckner. Buckner was vice president for the Jens-Marie Oil Company. The home is in the Spanish mission revival style and has shaped parapets at the upstairs dormers and over the entry to the porch.

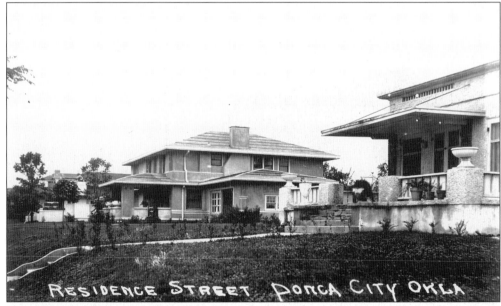

NORTH TENTH STREET, PONCA CITY. Tenth Street in Ponca City bordered the Marland golf course and was soon lined with fine homes. These two homes, the Alcorn and Pickeral home in the center and the McFadden home on the right, both enjoyed that view. The Alcorn/Pickeral home was designed by Elmer Bolliet of Kansas City in the prairie style.

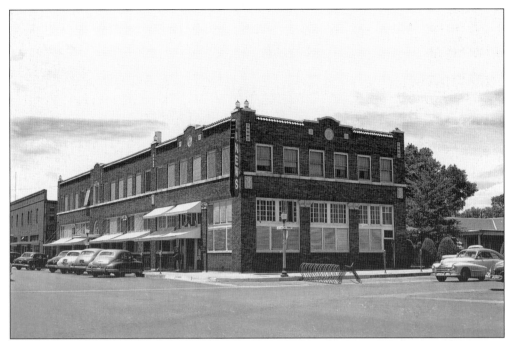

PONCA CITY NEWS, PONCA CITY. Clyde Woodruff of Fort Worth, Texas, was the architect for the Ponca City News building, constructed in 1924. The *Ponca City News* was funded by Lew Wentz, an ardent Republican, as a voice for the party in Ponca City. Wentz also funded the creation of the *Blackwell Journal* to compete with the more Democrat-leaning *Tribune*. Both papers were successful, and their competitors soon closed.

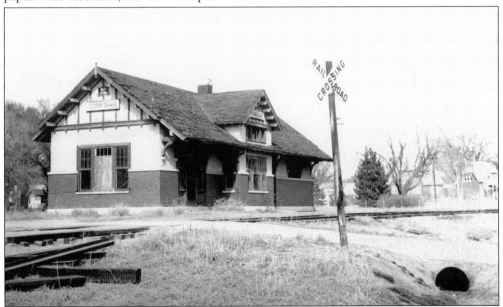

ROCK ISLAND DEPOT, TONKAWA (DEMOLISHED). The arrival of a new rail line was big news in 1927, and the towns on the new route (Ponca City, Tonkawa) were quickly provided new depots to handle the freight and people. The Tonkawa depot was a masonry building with dark red brick veneer below the stuccoed main wall. (Courtesy of the Tonkawa Historical Society.)

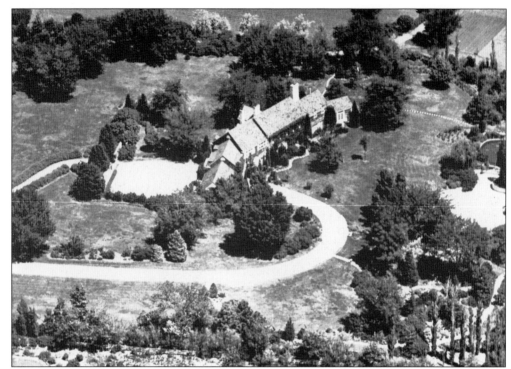

CLEARY HOUSE, PONCA CITY. John Duncan Forsyth, the Tulsa architect responsible for the design of the Marland Mansion (page 93), was also the architect for this charming but very large Colonial Revival home. The rambling home was built for Jack Cleary, the vice president of land acquisition for the Marland Oil Company in 1923. It sat originally in the center of a large estate, and outbuildings included a large stable. The grounds were landscaped by Henry Hatashita, the Kansas-educated gardener for E. W. Marland. The home was constructed on the east side of the Hillcrest addition, known for the fine large homes belonging to executives of the Marland Oil Company.

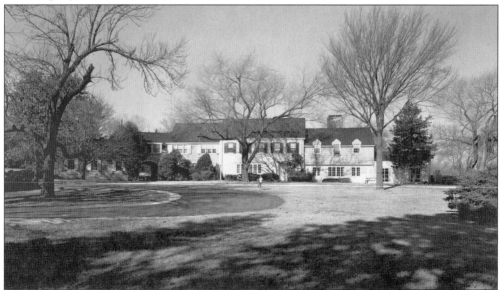

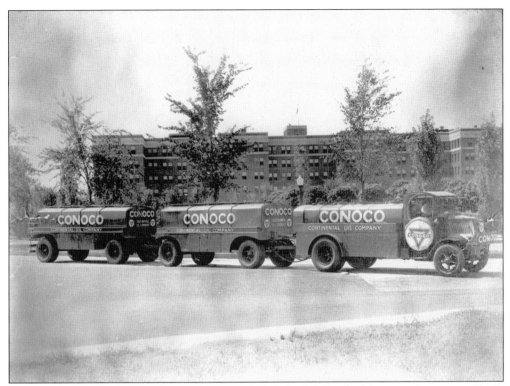

MARLAND OFFICE BUILDING, PONCA CITY. The Marland Office building was the center of both the worldwide Marland Oil Company and the Marland Model City. Designed by the architectural firm of Solomon Andrew Layton, this building was the largest office building in Ponca City when constructed in 1919 and was further enlarged in 1926. The complex as designed featured a large oval between the office building and the street, clubhouse buildings for men and women, tennis courts, and a baseball field (being used for football in the picture below). The building is of red brick with a classical entry on the north side, facing the oval. It is trimmed with stone at the cornice and below the top-floor windows. (Below, courtesy of the Marland Mansion.)

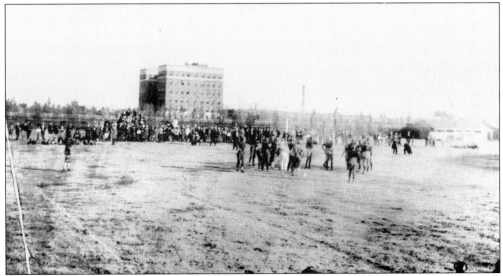

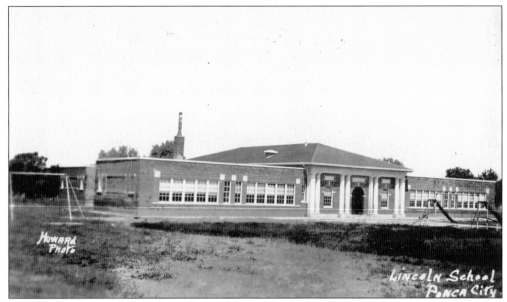

Lincoln School, Ponca City (Altered). Another school building designed by the firm of Solomon Andrew Layton, the Lincoln School was the first ward school in Ponca City and served the west side of town. It cost $70,475 to build and opened for its first students on January 28, 1920. The one-story red brick building is classical in style, with Ionic columns in pairs on the entry side.

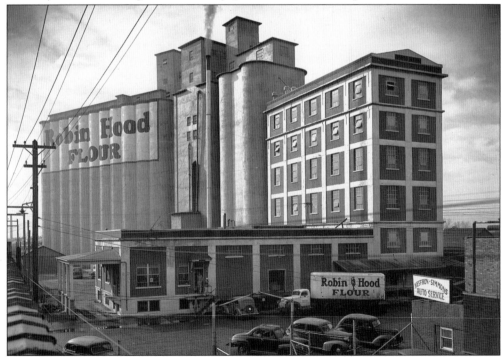

Ponca City Milling Company. Daniel J. Donahoe purchased a small flour mill on this site in 1897, and by 1919, it had expanded to the business seen here. The offices and warehouse space was added that year, and cost Donahoe over $20,000. Closed for many years, the mill and grain elevators are still one of the first things people see when approaching Ponca City.

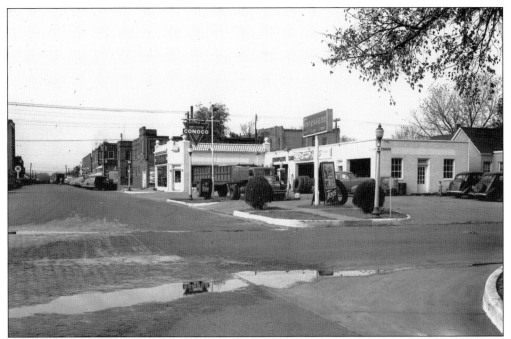

THE FIRESTONE STORE, PONCA CITY. Costing $11,000 when completed in 1919, this building featured decorative cast globes atop the piers of the front facade with clay tile accent between. The building, although brick, was designed to be painted white. With four bays, this was one of the largest service stations in Ponca City at the time.

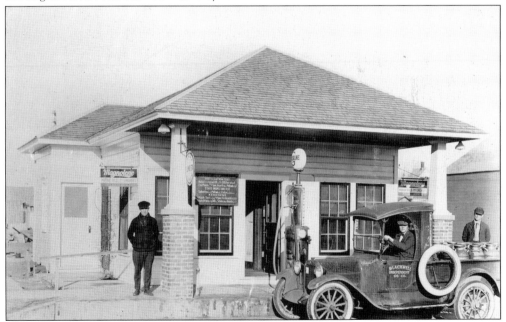

BLACKWELL INDEPENDENT OIL COMPANY STATION. This service station is in the craftsman style, with squared columns on brick piers, just like the front porches of neighboring bungalows. It has electric lights at each corner of the canopy, a feature seen often on service stations built by the larger oil companies. (Courtesy of the Top of Oklahoma Historical Society.)

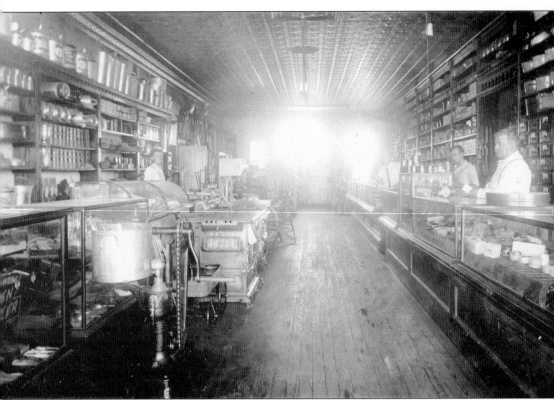

BRALY HARDWARE STORE, NARDIN. Although the building was constructed in 1905, this view of the interior of the store shows that the store was still a thriving enterprise in 1930 and had been updated over time. The store has a fashionable tin ceiling and numerous glass display cases, and is flooded with light from the front windows augmented by the clerestory windows above. On display are stoves, cream separators, a child's wagon, water pumps, and a display case dedicated to Keen Kutter knives. Hardware stores like this, that served a large number of farmers, had to be able to provide diverse merchandise to keep the farms operational, from nuts and bolts and nails to cans for kerosene. Owner Ben Braly is shown in the right foreground, and his sons Homer and Louie are in the background. (Courtesy of L. V. Crow, Friends of Nardin.)

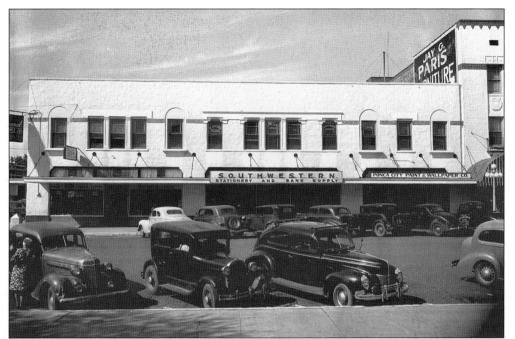

ROYALTY BUILDING, PONCA CITY. Designed by Tulsa architect John Duncan Forsyth, the Royalty building is one of Ponca City's many Spanish mission revival buildings. It features a tiled belt course above the second-story windows, balconets under the arched second floor windows, and an elaborate tile door surround on the west facade. The building was built by E. W. Marland in 1923, one of two on this block of downtown Ponca City.

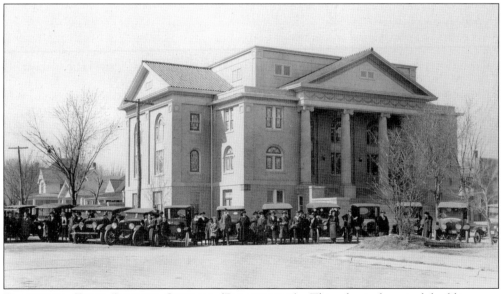

BLACKWELL FIRST BAPTIST CHURCH (DEMOLISHED). This classical revival building was constructed in 1919 on the site of Blackwell's original Baptist church. It had two-story Ionic columns supporting its cornice, which is further decorated with swags of fruit or flowers. The windows and doors on the entry porch are also two stories in height, divided at the floor level with panels. The building burned on March 10, 1950.

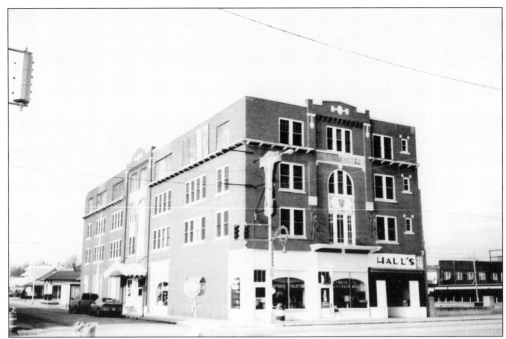

HOTELS IN TONKAWA AND BLACKWELL. The Larkin Hotel, above, and the Tonkawa Hotel, below, were constructed to serve the growing demand for hotel space as the oil boom continued to bring people to Kay County. The four-story Larkin was built in the early 1920s by John Larkin and had 66 rooms, 48 with attached bathrooms. It has a unique balcony in the center of the facade, supported by ornate scrolled iron. The Larkin's dining room was a popular place to meet in Blackwell. The Tonkawa hotel was constructed by 50 local shareholders in 1924. The Tonkawa Hotel was partially destroyed by fire, but the Larkin still stands proudly in downtown Blackwell. (Tonkawa Hotel courtesy of the Tonkawa Historical Society.)

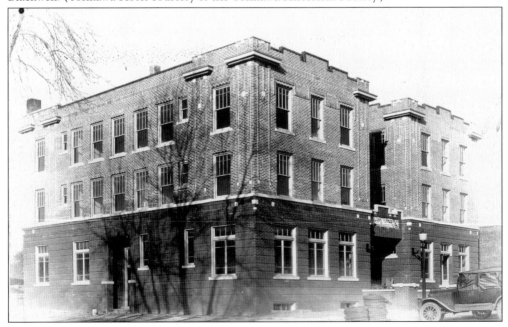

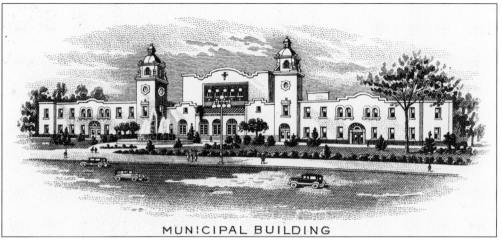

MUNICIPAL BUILDING

PONCA CITY CIVIC CENTER COMPLEX. In 1922, Solomon Andrew Layton returned to Ponca City to create additions to the Civic Center Auditorium. The addition started with towers flanking the original auditorium, to visually anchor the building's center. The three-story towers are topped with domes in the Spanish mission revival style and feature ornate round blind windows (originally grills) and second-floor windows with decorative tops. The shaped parapets of each wing mirror that of the original building. City offices were originally in the west wing, and the east wing housed the fire and police departments. The complex was renovated in the late 1990s, but much of its original appearance was preserved. (Above, courtesy of Marland's Grand Home.)

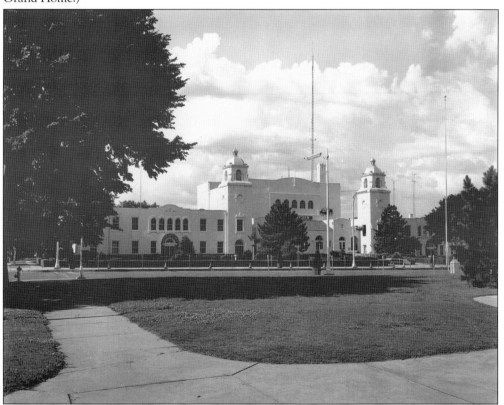

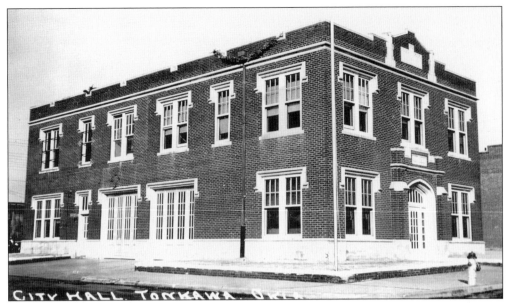

TONKAWA CITY HALL. The best example of the Gothic Revival style in Tonkawa is the city hall, built in 1923. Details evocative of the style include the hood molds over the windows, the buttressed entry, and the use of the Tudor arch for the door. Bands of limestone on the front are decorated with trefoils and finales. It was constructed by Ellis Charles and Company for $20,000. (Courtesy of the Tonkawa Historical Society.)

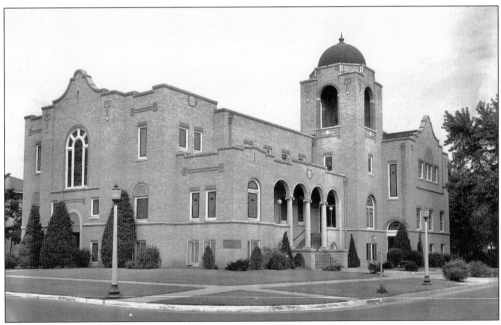

FIRST CHRISTIAN CHURCH, PONCA CITY. Van Slyke and Woodruff of Oklahoma City designed this Mediterranean Revival–style church, with brick walls and a decorative arcade-type entry on the east. The domed tower is one of its most dominant features. After purchasing the land for $12,000 in 1920, the congregation broke ground for this $100,000 church on April 9, 1923, and formally dedicated it on August 6, 1925.

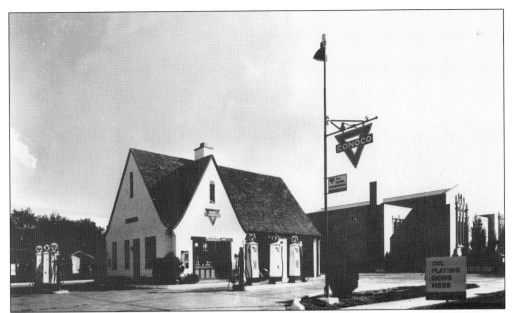

Conoco Service Station, Ponca City (Demolished). Located on the northeast corner of Fifth Street and Grand Avenue, this cottage-style gas station is similar to those originated by the Phillips Petroleum company. They were designed to blend into neighborhoods. The Continental Oil Company was a small Colorado distributor prior to its merger with Marland Oil Company in 1930.

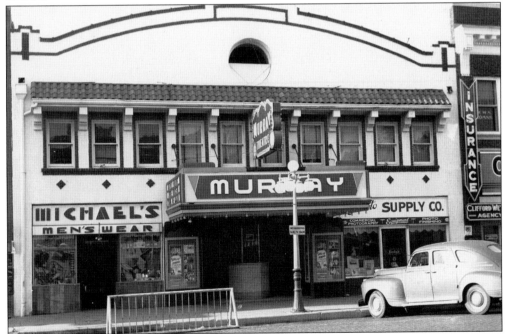

Murrey Theater, Ponca City (Altered). Another of Ponca City's five early theaters, the Murrey Theater was constructed in the Spanish mission revival style. It featured a full-width arched parapet and second-story windows topped by an awning of clay Spanish tile. Small retail space was provided on each side of the main entry, a common arrangement for early theaters.

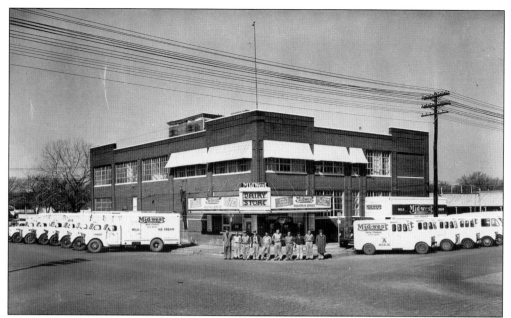

MIDWEST CREAMERY, PONCA CITY (DEMOLISHED). The Midwest creamery building cost $30,000 to build in 1923 and initially housed over $45,000 in equipment. It was designed as a two-story building, although the second floor was added only so that there would be room for anticipated future expansion. The large empty second-story space was used for various social events, including as a skating rink.

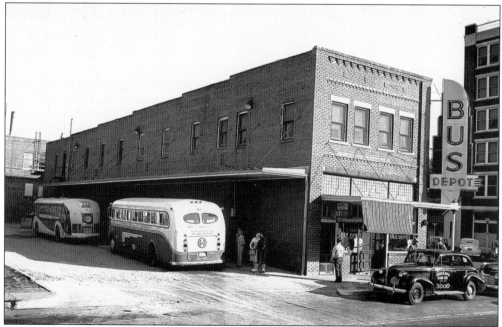

PONCA CITY BUS STATION. Bus transportation gained favor during and after World War II, and the Ponca City area was served through this brick building located on North First Street. The simple commercial-style building had a courtyard for the buses on the north side of the building, protected by an awning. The second floor provided hotel accommodations.

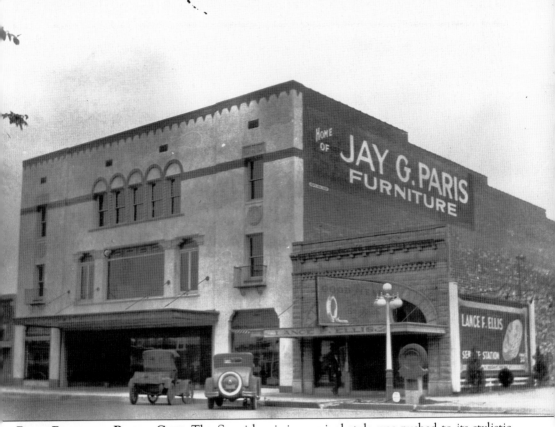

PARIS BUILDING, PONCA CITY. The Spanish mission revival style was pushed to its stylistic limits when John Duncan Forsyth designed this building. It was financed in 1927 by E. W. Marland expressly for the Paris furniture store and cost nearly $100,000 to erect. Details include a row of third-floor windows in blind arches separated by twisted columns, massive columns with ornate capitals dividing the second-floor windows, cast-iron balconies supported by scrolled brackets, and decorative niches of medallions and coats of arms. The first floor of the interior was two stories in height originally, with a mezzanine level around the exterior. In later years, canvas awnings were installed over the two side bays, but the original metal awning was not altered and remains today. The small stone building next door, with an arched opening for the entire facade, was demolished to build the Paris Building annex in 1929.

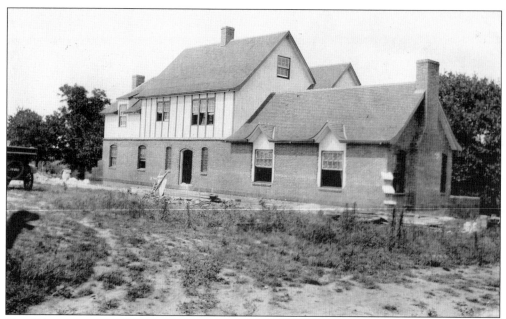

THE SHALLENBERGER HOME, PONCA CITY. This home was built for George Shallenberger, a vice president of Marland Oil Company, in the Hillcrest addition. This Tudor-style home was extensively landscaped, planning for which was started by the Shallenbergers even before the home was completed. The entry is enhanced by a Tudor arch, and half-timbering decorates the second story. It is one of six homes built for Marland executives in that neighborhood, many of which were designed by John Duncan Forsyth. The neighborhood was the site of many fashionable parties during the heyday of Marland Oil, and a donkey was a guest at the open house held for the Shallenbergers in 1923. (Courtesy of David and Terry Bell.)

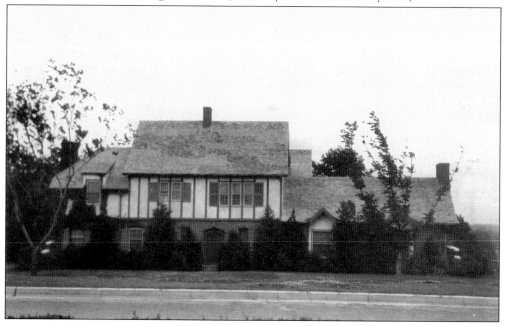

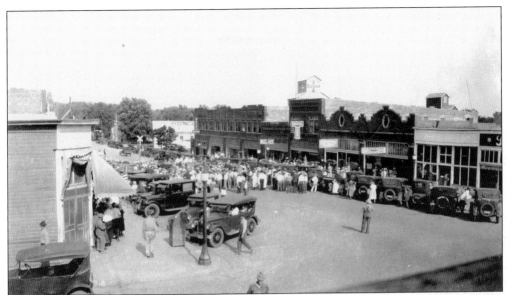

Two Street Scenes. Both Tonkawa and Blackwell had collections of brick buildings lining the streets in the 1920s. Above is Tonkawa, around 1923, on a busy day. Tonkawa experienced a large influx of oil wealth at this time, due to the discovery of the nearby Three Sands Field in the spring of that year. In Blackwell, below, West Blackwell Avenue is the site of the *Tribune* newspaper offices, the Blackwell Post Office, and further down on the left side, the Palace Theater. Many of the buildings shown in both these pictures are still standing today. (Above, courtesy of the Tonkawa Historical Society.)

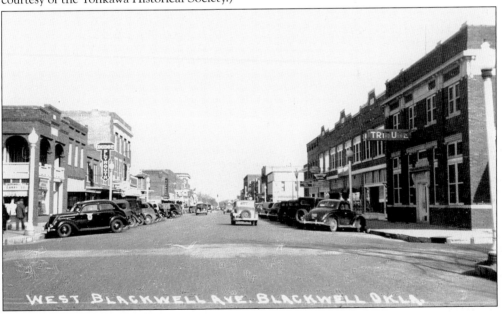

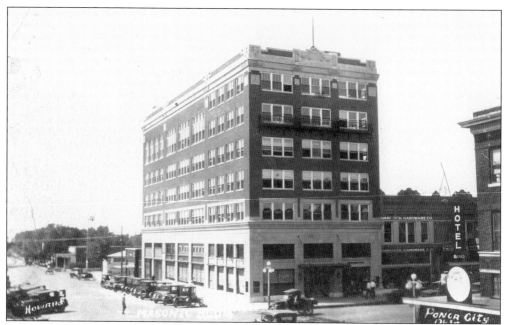

MASONIC BUILDING, PONCA CITY. Designed by Smith and Senter in 1922, the Ponca City Masonic Lodge constructed this five-story office building at a cost of over $325,000. With only the top floors dedicated to lodge functions, the remaining floors were used to generate income for the organization. Security Bank was the occupant of the first floor, with Wentz Oil company on the second floor. The building was originally enhanced with a classically designed entry and cornice, wrought iron balconets on the fourth floor, and corner piers topped with base relief carvings in square blocks of granite. In 1956, the bank was remodeled, at which time the interior lost the appearance shown below (see page 124). At that time, it also opened the first motor bank in Ponca City—a small window on the back at the alley.

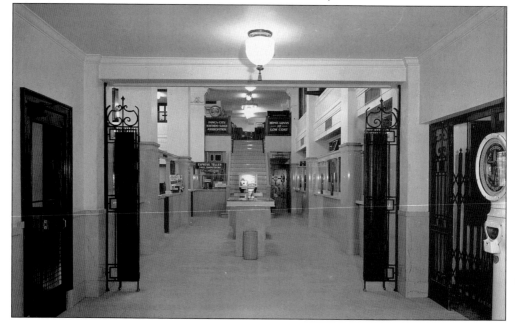

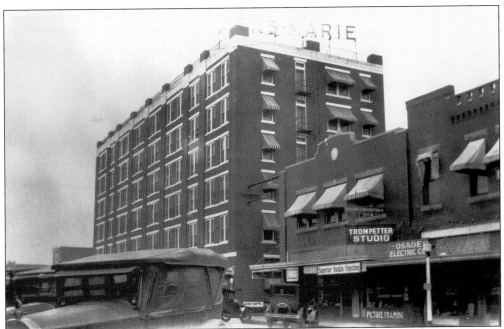

JENS-MARIE HOTEL, PONCA CITY (DEMOLISHED). The six-story Jens-Marie Hotel opened on February 24, 1922, and cost its builders over $350,000. It was built by the partners who founded the Jens-Marie Oil Company, Jim VanWinkle, Dan Mooney, J. J. Young, and Henry Buckner. They spent another $100,000 furnishing the 128 rooms and 85 bathrooms. The main lobby and staircase were paneled in oak. The Jens-Marie was demolished by implosion in 1978.

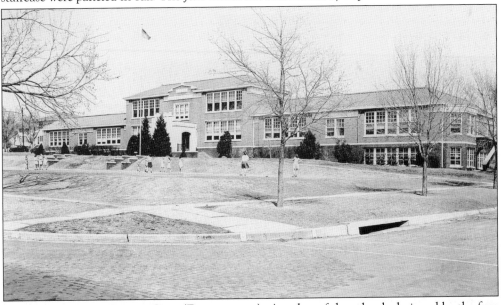

GARFIELD SCHOOL, PONCA CITY (DEMOLISHED). Another of the schools designed by the firm of Smith and Senter, Garfield served the mid-south part of Ponca City. It was decorated with lavish use of decorative terra-cotta surrounding the cornice and at the entry. Built in 1924, additions were made in 1936. A total of 45 percent of that cost was paid by the WPA. Garfield was demolished in 2005.

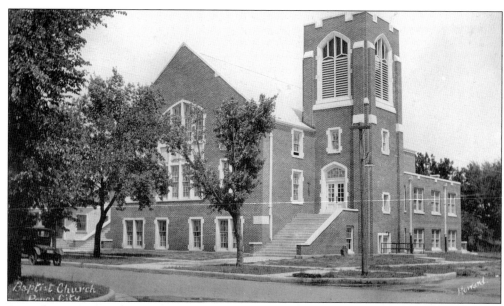

FIRST BAPTIST CHURCH, PONCA CITY (DEMOLISHED). The First Baptist Church of Ponca City was a fine example of the late Gothic Revival style and features included a Tudor arch door; dressed granite details at windows, parapet, and eaves; and a buttressed tower. This style was extremely popular for churches of this era, not only in Kay County but across the United States. The cornerstone for the church was laid on September 2, 1923, and first services were held on July 6, 1924. The church was destroyed by fire on January 24, 1949, in what was described as the largest and most costly fire in Ponca City History. (Above, courtesy of the First Baptist Church, Ponca City.)

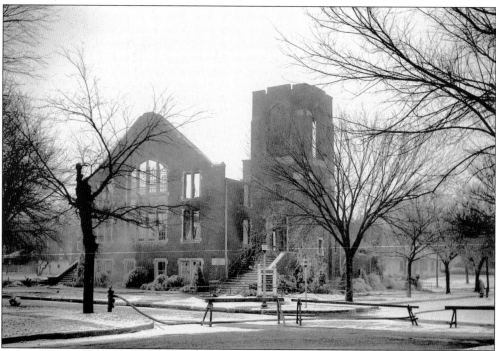

SALVATION ARMY CITADEL, PONCA CITY. The 1923 Salvation Army Citadel in Ponca City is an example of the late commercial style as applied to a noncommercial building. It features a unique parapet accented by vertical curved-top piers that extend above the cornice, and the center of the cornice is decorated with a shaped parapet as well. Stone is used for accents at the door, cornice, and corners of windows.

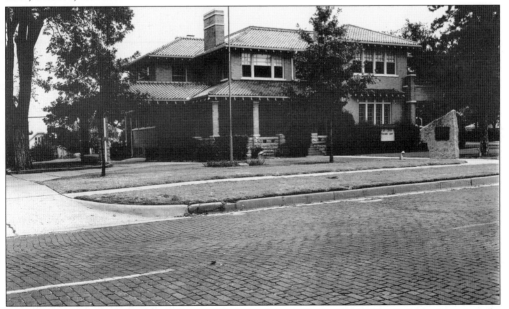

SOLDANI MANSION, PONCA CITY. The Anthony Godance Soldani Mansion, in the Mediterranean Revival style, was constructed in 1925. Built of hard-fired buff brick, and with green roof tiles imported from France, it cost $92,000. The architect of the 8,000-square-foot home was George Cannon of Ponca City, and O. F. Keck was the builder.

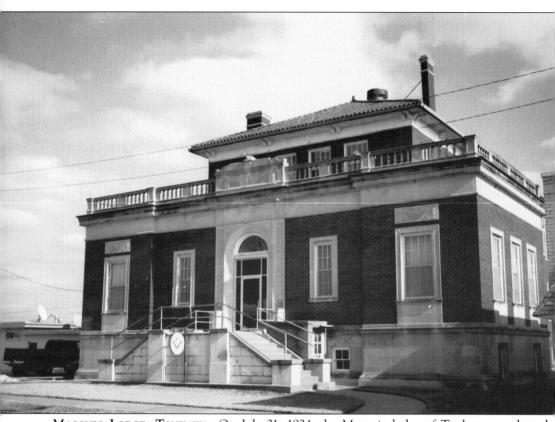

MASONIC LODGE, TONKAWA. On July 21, 1924, the Masonic lodge of Tonkawa conducted traditional rituals to lay the cornerstone for this building, and it was completed and occupied in 1925. Architects Hawk and Parr of Oklahoma City were responsible for the design. The exterior features a stone basement level and window surrounds, an entry surround decorated with Renaissance Revival details, and a granite balustrade at the cornice. Over the windows, the inset granite rectangles are ornamented with Renaissance-style swags. One feature that was lauded when the building was completed was the roof garden, a flat roof that was accessible to the third-floor lobby. The building was noted at the time of its completion for its spectacular light fixtures. The main entry level is the Eastern Star meeting room, and the upper floor is the Masonic lodge.

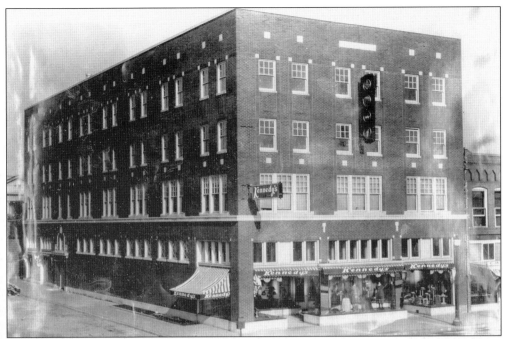

MASONIC BUILDING, BLACKWELL. The Blackwell Masonic Building is a four-story building in the commercial style. It is one of the three tallest buildings in downtown Blackwell. The top two floors are dedicated to lodge activities, and the second floor provided needed office space to the community. The main floor has always been used for retail. (Courtesy of the Blackwell Masonic Lodge.)

RITZ THEATER, PONCA CITY. After the Ritz Theater was constructed in 1926, Ponca City could boast of having four movie theaters. In the commercial style, the building has a curved parapet with a decorative center panel where the marquee once hung. Windows are highlighted with stone blocks at the corners, and a metal awning extends from one end of the building to the other.

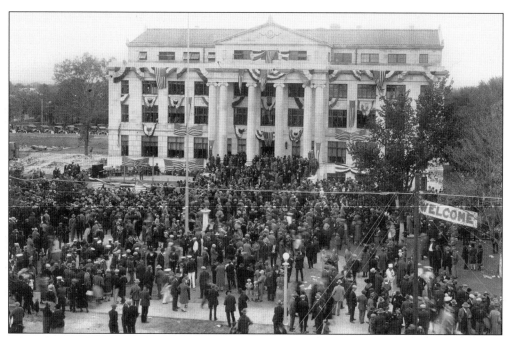

KAY COUNTY COURTHOUSE, NEWKIRK. Clyde Woodruff of Fort Worth, Texas, was the architect for the Kay County Courthouse, completed in 1926. The classical revival–style building was paid for before it was completed, thanks to a three-year levy voted for by county residents in 1922. Oil industries paid 37 percent of the total cost of the courthouse, which was $291,999. (Courtesy of Newkirk Main Street.)

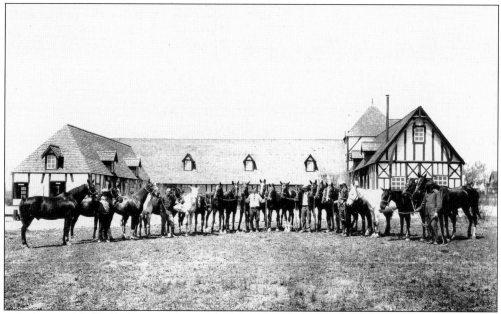

MARLAND STABLES, PONCA CITY (DEMOLISHED). The Marland Stables were the center of activity when Marland hosted foxhunts and polo games. The stables were a large complex made up of a U-shaped two-story main building with dormers and a tower, all in the Tudor Revival style. (Courtesy of Marland's Grand Home.)

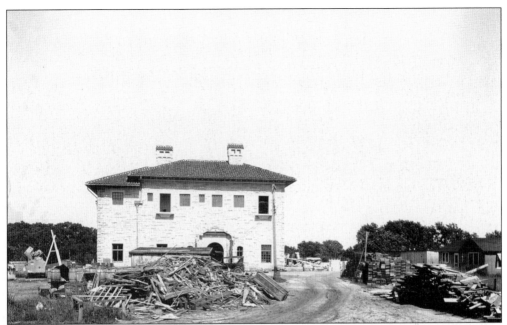

MARLAND MANSION, PONCA CITY. The Italian Renaissance–style Marland Mansion was designed by Beaux-Arts-trained architect John Duncan Forsyth of Tulsa, and cost $2.5 million to build in 1928. With 43,651 square feet, 12 bathrooms, an elevator, and a handball court, it was quickly recognized as one of the finest homes in Oklahoma. Stonemasons and contractors as well as artists such as muralist Vincent Magliotti, stone carver Pelligrini, and sculptor Conrad M. Berglund worked for three years to complete the residence. Marland served as the 10th governor of the state of Oklahoma and was also elected to the U.S. Congress. E. W. Marland died on October 3, 1941. The Marland Mansion is listed on the National Register of Historic Places as a national historic landmark. (Above, courtesy of Marland's Grand Home; below, courtesy of Marland Mansion.)

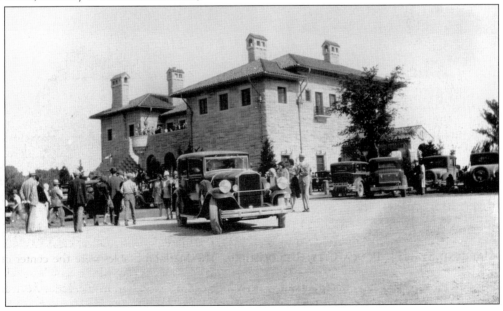

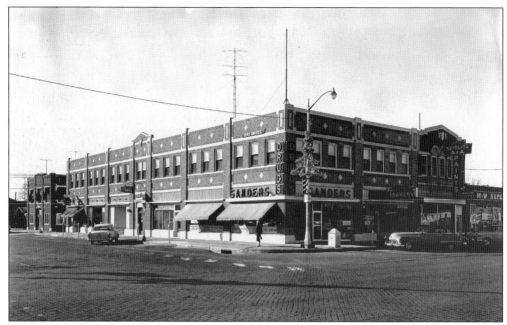

WAGGONER HOTEL, PONCA CITY (DEMOLISHED). The Waggoner Hotel (built in 1926) was designed by Smith and Senter, architects for many other Kay County buildings. The commercial-style building also had elements of the Renaissance Revival, such as the stone cartouche above the hotel entry in the middle of the sidewall. The building and its neighbor were lost to fire in the 1980s.

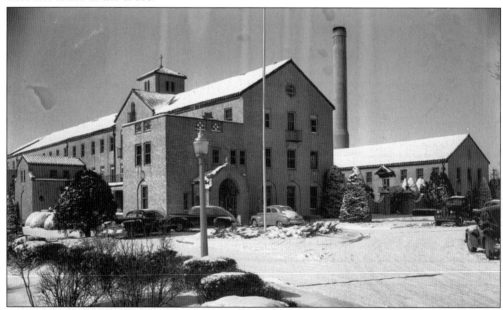

PONCA CITY HOSPITAL (ALTERED). In 1925, the "Hospital on the Hill" was constructed, thanks to a donation of $250,000 provided by E. W. Marland. The Spanish mission revival–style building was decorated with rough stucco and an entry arcade of simple columns. The side entries had a scroll-shaped parapet, and iron balconies were used on all the main elevations. A tower provided a Spanish-style backdrop.

DOUGLASS APARTMENTS, PONCA CITY. To provide room for the ever-expanding workforce at the Marland Oil Company, Dr. J. A. Douglass built this apartment building on the west side of downtown in 1927. The upper balcony is framed with decorative stone arches. The front of the main floor was reserved for retail use. Many of the apartments had a fireplace of decorated tile, all of which were different.

WEST DYERS, BLACKWELL. Located on West Blackwell Avenue, the West Dyer's store was home for the furniture business for many years. It is decorated with a corbelled pediment, with rows of alternating recessed and flush bricks above. Both floors of the building were used for furniture sales. The company originally started out selling clothing, and was the oldest retail business in Kay County when it closed.

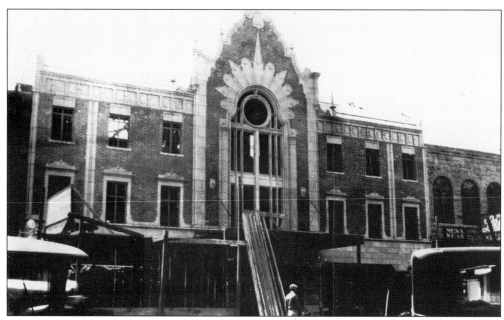

PONCAN THEATRE, PONCA CITY. The Boller brothers of Kansas City designed this atmospheric theater as a "legitimate" theater in 1927. It was financed by local businessmen George Brett, Eugene Wetzel, C. F. Calkins, and Dr. J. A. Douglass and cost $280,000 to construct. It also featured a $22,000 Wurlitzer organ. The stage was host to performers such as Will Rogers, Ethel Barrymore, Walter Huston, and Sally Rand. In 1929, it was converted to exhibit sound movies. The exterior is decorated with a scrolled pediment, twisted columns, and coats of arms along the cornice. The interior of the theater was designed to look like a Spanish garden, with a blue sky and massive interior dome. The Poncan Theatre is listed on the National Register of Historic Places.

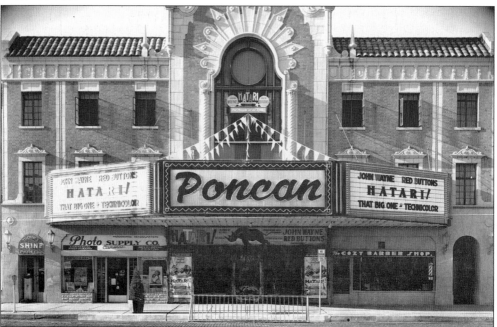

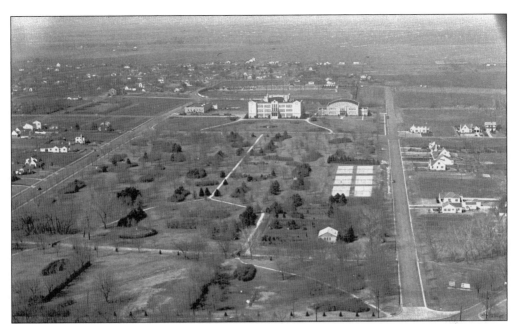

PONCA CITY HIGH SCHOOL. The largest of the schools designed by Smith and Senter for Ponca City, the high school was another of the Spanish mission revival buildings built in the 1920s. It was built on the north edge of town, in an area of mostly empty land. Costing over $300,000, the exterior was decorated with wrought iron, decorative stonework, and scrolled pediments on each end bay.

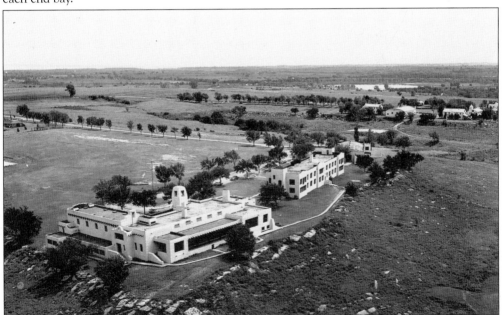

MARLAND INSTITUTE, PONCA CITY (DEMOLISHED). The Marland Institute was established by Marland Oil as an in-house school and country club. It was built in 1927. The building at the lower left was called the "Quah-Ta-See-da" club. In the Spanish mission revival style, it had battered walls, a flat roof, and vigas. Mission-style shaped parapets adorned the entries. It was later known as the Ponca Military Academy.

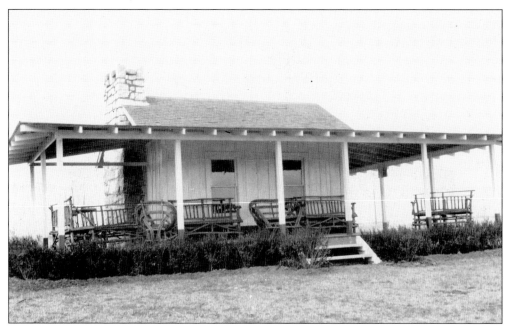

POLO CLUB HOUSE, PONCA CITY. Another reminder of activities favored by the Marland executives is the polo clubhouse building. The polo field and clubhouse were located at the north end of the downtown Marland Estate, north of Marland's Grand Home and the Marland golf course. (Courtesy of David and Terry Bell.)

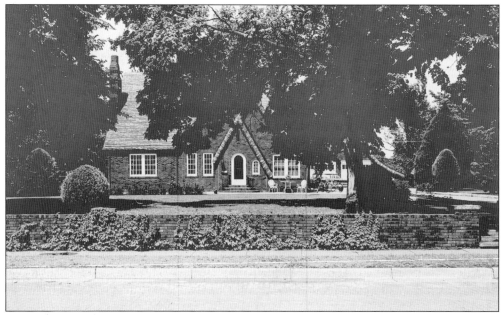

MEEK RESIDENCE, PONCA CITY. George Cannon of Ponca City was the architect for this Tudor-style home. The false thatched roof gives it a romantic appearance. L. K. Meek was a member of the school board when the nearby high school was built, and built here to prove that people would build homes near the new high school (see page 97).

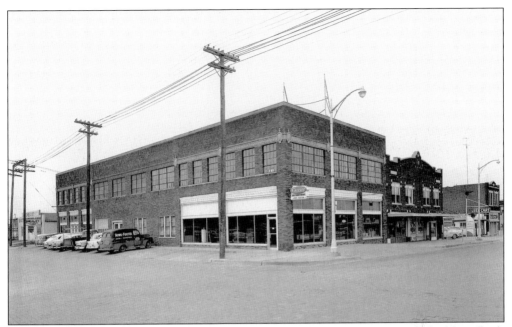

SAVAGE MOTOR COMPANY, PONCA CITY. The Orville Savage Motor Company building (built in 1927) is another example of the impact that automobiles had in the 1920s. This car dealership, in the commercial style, is accented with a polychromatic brick treatment in the upper walls and enhanced with classical cartouches and decorative stonework over the second-story windows on the front and side. George Cannon was the architect.

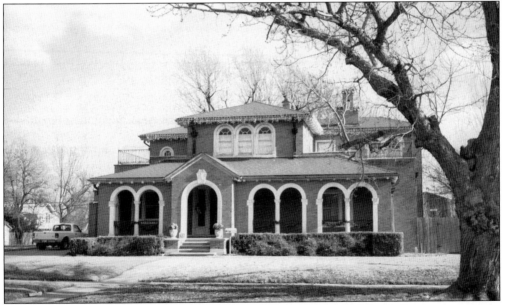

SARAH MAHONEY HOUSE, TONKAWA. Constructed in 1928, the Mahoney house was another home built with oil money, this time from the Three Sands field. Of buff brick with glazed terra-cotta ornament, the home was designed by Sorey and Vahlberg of Oklahoma City. The porch, with arched openings supported by twisted columns, is an impressive detail. The Mahoney house is listed on the National Register of Historic Places.

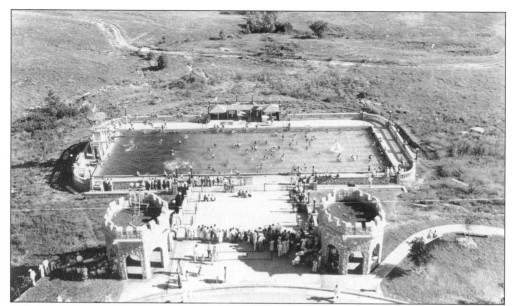

WENTZ CAMP AND POOL, PONCA CITY. Wentz Camp was established in 1925 by Lew Wentz as a gift to the children of the area. The stone cabins, in the forms of castle keeps, were constructed first, followed by the 100-foot-by-50-foot pool in 1928. The pool has dressing rooms below the decking, a stone balustrade, and originally was wired with multicolored lights around the edge. The pool was the site of the Miss Ponca City and Baby Ponca contests. The Baby Ponca contest was open to "unmarried ladies under five." Wentz donated the camp to the City of Ponca City in 1935.

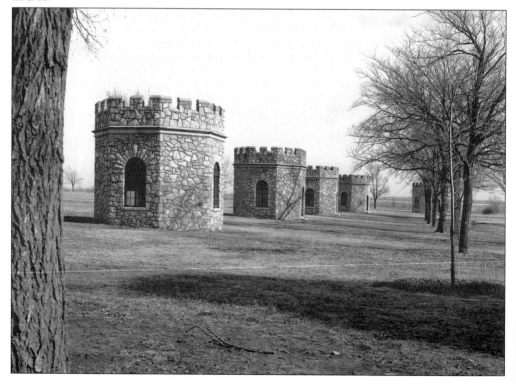

KRESS BUILDING, PONCA CITY. The Kress building, local outlet for the national chain of retail stores, was designed by an in-house architect and shared details with other buildings of the chain. These details include the terra-cotta Kress emblem at the pediment over the center section. It was constructed in 1929 at a cost of $69,000.

TBO BUILDING, PONCA CITY. WBBZ, the first AM radio station in northern Oklahoma, moved into this building in the early 1930s. The building's exterior has decorative elements of terra-cotta including the diamond over the door that says "TBO" and the date of construction, 1929. The pier tops along the facade are decorated with art deco terra-cotta tops.

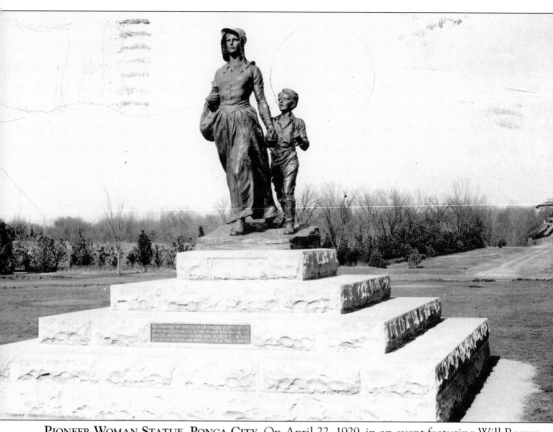

PIONEER WOMAN STATUE, PONCA CITY. On April 22, 1929, in an event featuring Will Rogers and attended by over 4,000 people, this 12-foot-high bronze statue on an 18-foot limestone base was donated to the state of Oklahoma by E. W. Marland. It was designed to honor the women who helped homestead Oklahoma. The 12 models of proposed statues toured Boston, Philadelphia, Pittsburg, Chicago, Minneapolis, St. Paul, Detroit, Dallas, Fort Worth, Oklahoma City, and Ponca City to allow people to vote for their favorite. Of the over 750,000 votes cast, the model of the statue as sculpted by Bryant Baker of New York was the favorite. In the background is the Marland Mansion, connected to the statue by a vista lined with trees and statues. The vista was intended to frame the view of the statue from the mansion, and the view of Ponca City beyond. Later it was paved and is now part of a Ponca City subdivision. The *Pioneer Woman* is listed on the National Register of Historic Places.

Three

DEPRESSION AND WAR
BUILDINGS FROM 1930 TO 1946

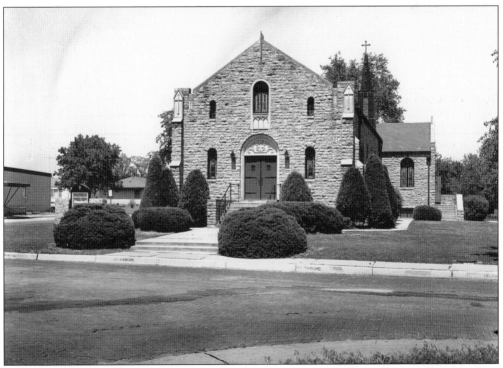

FIRST LUTHERAN CHURCH, PONCA CITY. The modified perpendicular Gothic-style First Lutheran Church was designed by George Cannon and dedicated on December 16, 1934. The building is enhanced with buttresses at each end of the facade decorated with a Romanesque cross carved in stone at the top. The heavy doors are decorated with wrought iron hinges and topped by a carved spandrel. The bell tower and spire is on the east side of the building, topped by a cross.

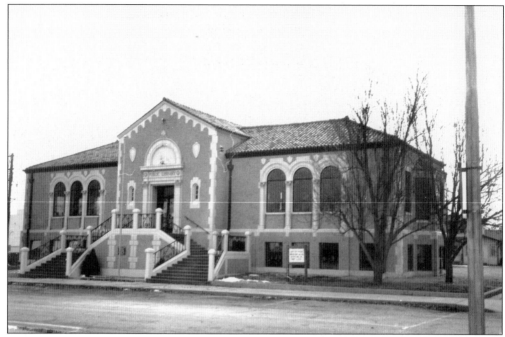

BLACKWELL LIBRARY. In 1931, the community of Blackwell received this new library, and it was completely financed before construction was completed—thanks to a two-mill levy that the city had added to its charter years before. The building cost $35,000 to construct, and is in the Mediterranean Revival style. The facade is symmetrically arranged, with the entry in the center. The rows of tall arched windows, ornamented with wrought iron balconets, are separated by twisted columns. Decorative cartouches are placed on each side of the main entry, and shields are set above and to the side of each window. The roof is of Spanish clay tile. The interior was furnished at the time of construction. In 1936, the library was home to 11,636 books.

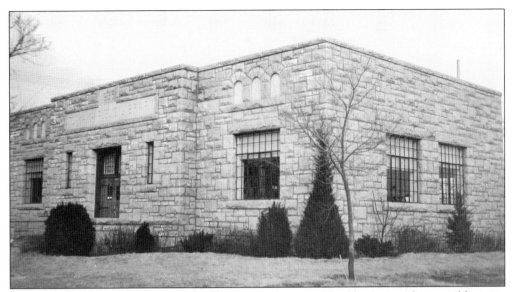

TONKAWA PUBLIC LIBRARY. Using a WPA grant, the city of Tonkawa erected its new library in 1935. It has shaped limestone for the coursed masonry walls and a large tablet carved with the name of the building and its date of construction over the entry. Each wing is enhanced with triple blind-arch windows set above metal casement windows at the main floor level. (Courtesy of Tonkawa Historical Society.)

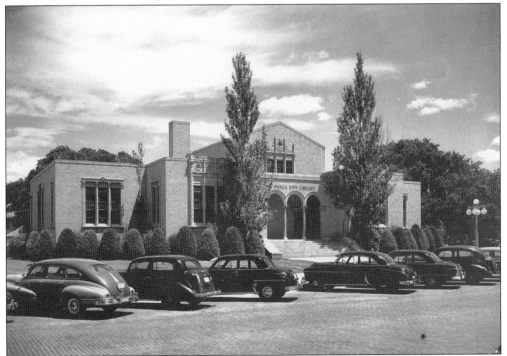

PONCA CITY PUBLIC LIBRARY. The Ponca City Public Library is built of buff-color brick and ornamented with terra-cotta details at windows, front arcade, and clerestory window of the main reading room. The Mediterranean Revival library was designed by George Cannon and constructed using WPA funds in 1935. It is also home to the Matzene art collection.

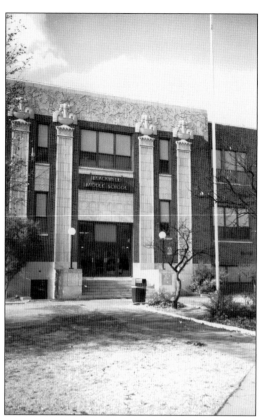

BLACKWELL HIGH SCHOOL. The *c.* 1934 Blackwell High School, now the Blackwell Middle School, is one of the few examples of high art deco in Kay County. The entry bay, with details of terra-cotta, includes columns terminated with urns or fountains and a cornice made up of exuberant foliate decoration in the art deco style.

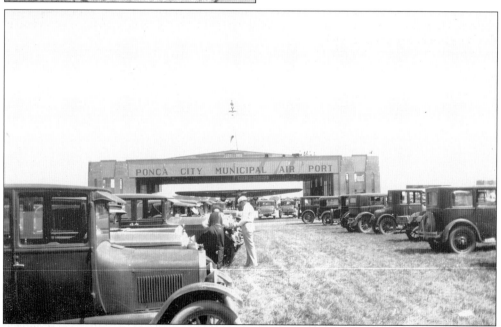

PONCA CITY AIRPORT. Recognizing the need for better air transportation facilities, the city of Ponca City constructed this large hangar and airport building. Tall brick towerlike structures anchor the massive span of the roof visually and are lit by the use of tall arched windows.

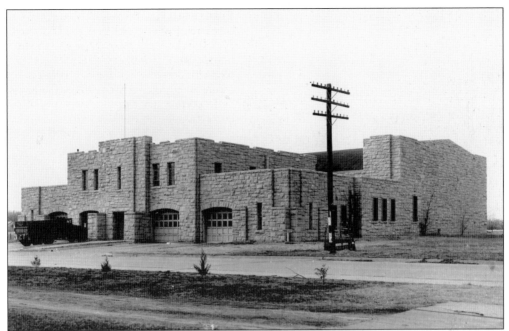

ARMORIES IN BLACKWELL AND TONKAWA. These two armories were constructed in 1936 as part of the WPA concern for armories across the United States in the mid-1930s. The Blackwell armory (below) is unique in Oklahoma in that it was constructed of brick with stone details. The Tonkawa armory (above) was designed by Bryan Nolan, architect for the WPA, and required 68,000 man-hours to build. Architecturally it is in the severe style of utilitarian buildings constructed by the WPA. Both armories are listed today on the National Register of Historic Places for their association with the WPA and national defense. (Above, courtesy of the Tonkawa Historical Society.)

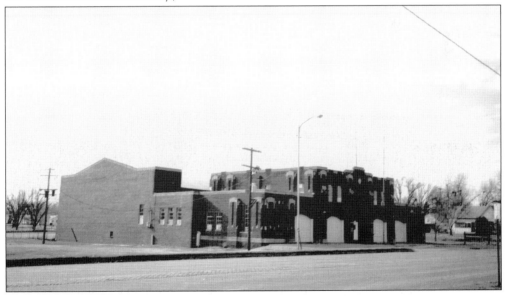

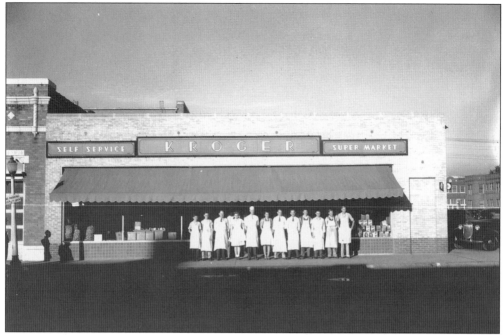

KROGER STORE, PONCA CITY. By the early 1940s, people were beginning to appreciate the convenience and selection provided by chain grocery stores as opposed to the neighborhood stores that predominated in earlier times. The Kroger store was one of the first large stores in Ponca City. The Independent Order of Odd Fellows lodge owned the building, and it was designed to accommodate a second floor, which was added later.

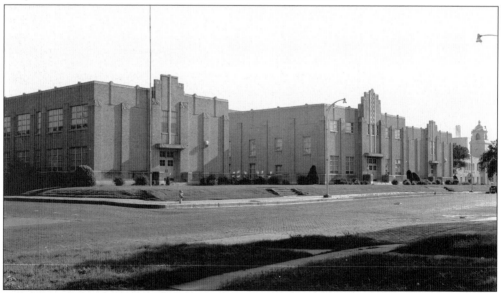

PONCA CITY EAST JUNIOR HIGH SCHOOL. Located on the site of three previous schools, including the original 1893 Ponca City school, this is one of the rare examples of art deco architecture in Ponca City. Stylized capitals adorn the facade, and each entry is surmounted by an elaborate art deco pediment. Winkler and Reid were the architects, and it was constructed in 1939.

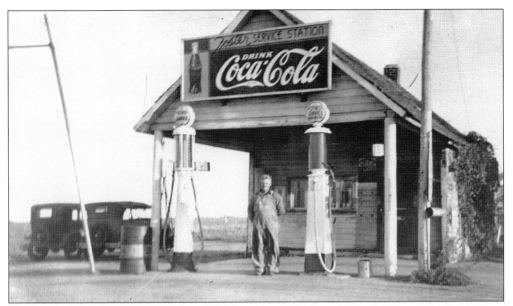

FOSTER SERVICE STATION, NARDIN (DEMOLISHED). Harking back to the more utilitarian gas stations of the second decade of the 20th century, the Foster Service Station is a simple frame building. Although this picture dates from 1939, the station is still using the earlier gravity-feed pumps. (Courtesy of L.V. Crow, Friends of Nardin.)

PORTER RESIDENCE, PLEASANT VIEW. A simple mid-century bungalow, the Porter residence is unique for its use of clinker brick and stone laid in a random pattern. The diamond-shaped shingles were an option for roofers of the decade, although not commonly used.

KIMBOROUGH RESIDENCE, PONCA CITY. The Kimborough residence is located in the south part of Ponca City and was the residence of the Rev. Kimborough, a highly esteemed black minister. Constructed of clay tile, the home has a false eyebrow dormer over the entry stairs and a full-width porch on the east side.

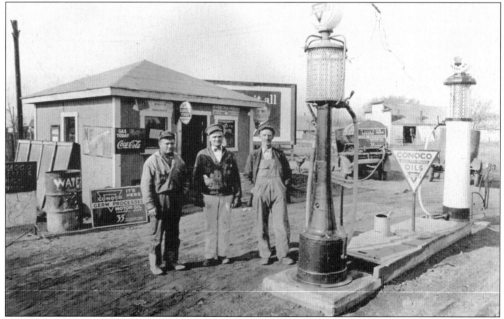

MAAS BROTHER SERVICE STATION, NARDIN. Brothers Klaus and John Maas, along with their uncle John Hasz, are shown in this picture in front of their gas station. The service station featured Conoco gasoline. This simple frame building with pyramidal roof was the most basic of service stations, although similar stations were found county-wide until the late 20th century. (Courtesy of L. V. Crow, Friends of Nardin)

Four

Peace and Stability
Buildings from 1947 to 1957

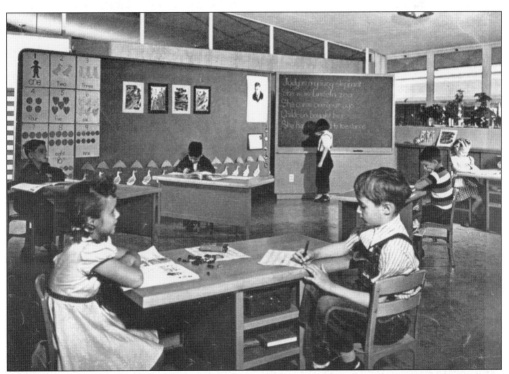

Huston School Interior, Blackwell. In 1948, the school board of Blackwell hired an unknown architectural firm, Caudill and Rowlett of College Station, to design a new grade school. Huston School was esteemed as a landmark innovation in schoolhouse design. The buildings were designed to capture the south sun, thereby filling the classrooms with light, and they were designed to use natural ventilation. (Courtesy of CRS Center, College of Architecture, Texas A&M University, College Station, Texas.)

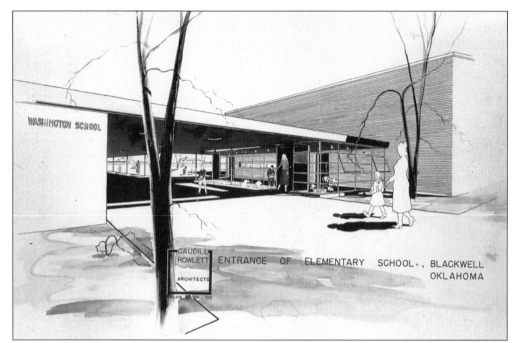

WASHINGTON SCHOOL, BLACKWELL. This architect's rendering of Washington School illustrates the architects' use of glass walls wherever practical, as well as the large expanses of covered area, both features of the early Caudill, Rowlett, and Smith–designed schools in Blackwell. This school was constructed to replace the original Baptist College building (see page 32). (Courtesy of CRS Center, College of Architecture, Texas A&M University, College Station, Texas.)

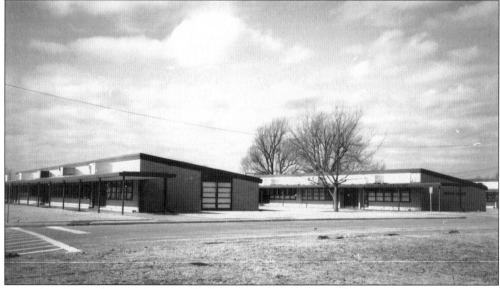

HUSTON SCHOOL, BLACKWELL. Shed roofs and covered walkways were instrumental in controlling the costs for the Blackwell schools, as shown in this view of Huston. The schools had no interior hallways; the students used the covered walkways to get from room to room. Even the bathrooms opened to the walkways. (Courtesy of CRS Center, College of Architecture, Texas A&M University, College Station, Texas.)

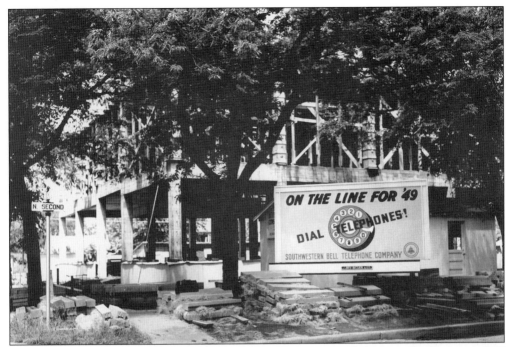

SOUTHWESTERN BELL BUILDING, PONCA CITY. This picture of the new Southwestern Bell building, taken on July 15, 1948, shows the purpose for the new building—it was to provide space for the new switching equipment needed for dial telephones. The building has concrete piers and floors.

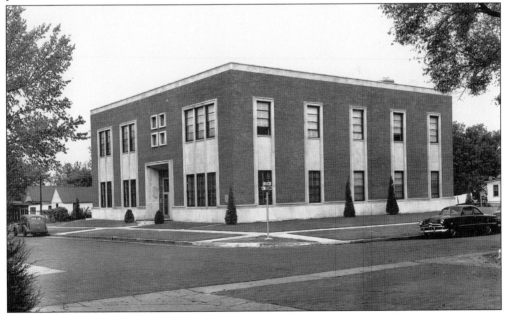

SOUTHWESTERN BELL BUILDING, PONCA CITY. M. D. Timberlake of Ponca City was the architect for this very modern building. With concrete floors and walls, brick veneer, and the use of simple stone details at the windows, doors, and foundation, it was about the most up-to-date building in the county when completed. A tower was added later in complementary style.

BLACKWELL PUBLIC SWIMMING POOL. The international style was not commonly used for buildings in Kay County, but the Blackwell Public Swimming Pool, constructed in 1949, is one exception. The center pavilion has an overhanging eave that continues down each side as a wall of sorts. Each wing is a dressing area, lit by curved walls of glass block windows. Even the lettering of the signs is as modern as the building.

WASHINGTON SCHOOL, PONCA CITY. Ponca City, like Blackwell, saw a need for modern schools as the children of World War II veterans reached school age. In 1952, this thoroughly modern building designed by M. D. Timberlake was opened, replacing a building that had been used as a school for over 40 years.

FAULKNER HOUSE, BLACKWELL. Another design by the firm of Caudill, Rowlett and Smith of College Station, Texas, is this very modern home. It has windows completed surrounding the walls just below the roof, made possible by the structural roof supported on iron columns. The brick walls provide privacy for all the street-side rooms, while the upper windows provide necessary light. The firm even designed the landscape, including the wood privacy fence. The fence continues through a glass wall at the entry to divide the entry from the living room. Another unique feature of this home is a result of the roof support design; there are no interior load-bearing walls and rooms could be rearranged if needed. The home cost $26,000 and was designed to be air-conditioned. The home was designed in 1951 for Dr. Faulkner and his wife and has only one bedroom in its original configuration. (Courtesy of CRS Center, College of Architecture, Texas A&M University, College Station.)

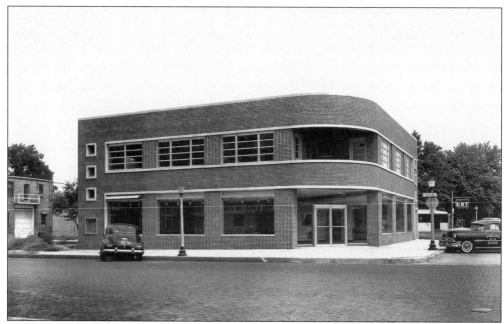

ANDERSON BUILDING, PONCA CITY. Another of the few international style buildings of Kay County is the Anderson shoe building. The construction of this building allowed that business to be among the first to relocate from Grand Avenue into a freestanding building. This trend eventually decimated the downtown business district of Kay County communities just as it did other towns across the United States.

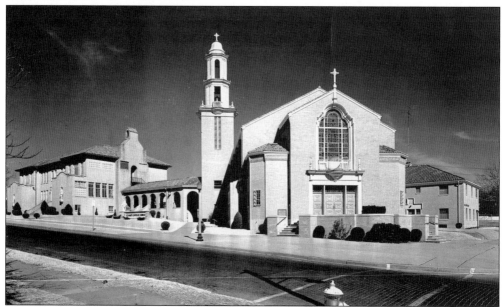

ST. MARY'S CATHOLIC CHURCH, PONCA CITY. This is an example of the Spanish mission revival as used in the 1950s. The building is of light brick accented with stone details. The stained-glass window at the entry, with scroll-shaped top, is fronted with iron railings and a half-round balcony. Beyond the three-tier bell tower and arcade is the St. Mary's School, built in 1928. The church was built in 1954.

PARKSIDE SCHOOL, BLACKWELL. The third of the schools in Blackwell designed by Caudill, Rowlett, and Smith is Parkside. J. J. Reardon was the general contractor, and the school was constructed in 1955. The school continued the philosophy of the firm first exhibited with Huston School in 1948, although in this case the roofs are flat and the classrooms are lit by skylights. Flat awnings are used again to cover exterior walkways connecting the rooms. All the schools by the firm are endowed with large windows to provide the maximum amount of light. William Caudill, founding principal of the firm, grew up in Holbert, Oklahoma, and was a graduate of Oklahoma State University. He was posthumously awarded the American Institute of Architects Gold Medal in 1983. (Drawing courtesy CRS Center, College of Architecture, Texas A&M University, College Station.)

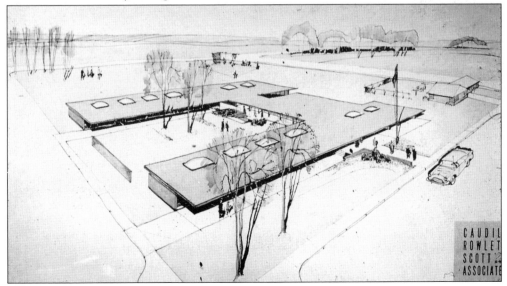

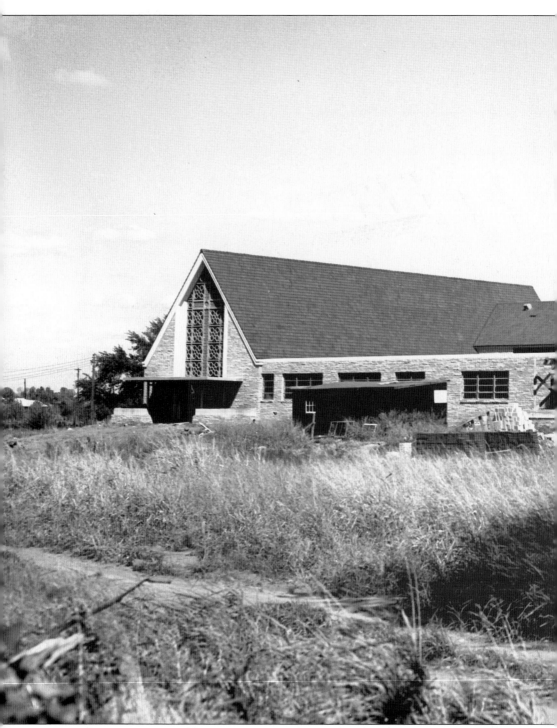

First Presbyterian Church, Ponca City. In 1955, the congregation of the First Presbyterian Church of Ponca City moved into this building located on a expansive lot on the east side of town. The new church building was dedicated in a month-long series of services between June 15 and July 17 of 1955. Even today, the towering spire is a significant part of the Ponca City

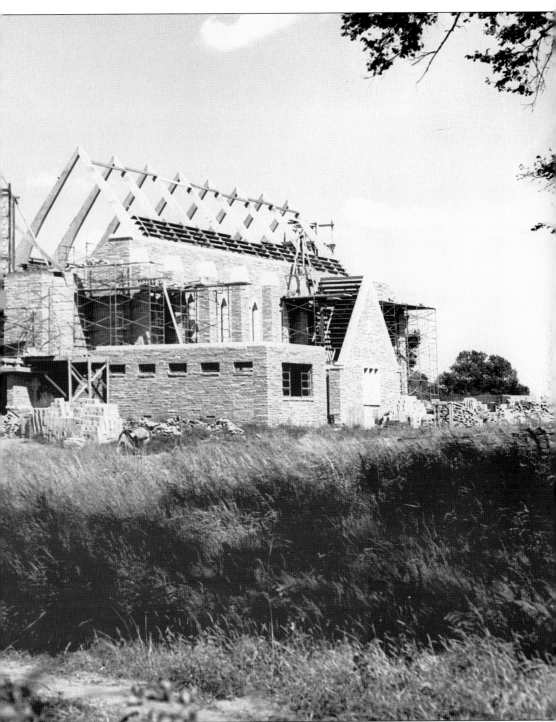

skyline. The church is a modern building, although it draws on Gothic styling cues for the roofline, tower, and interior. Cast metal is used for the grilles on the tower and on the fronts of the wings of the buildings.

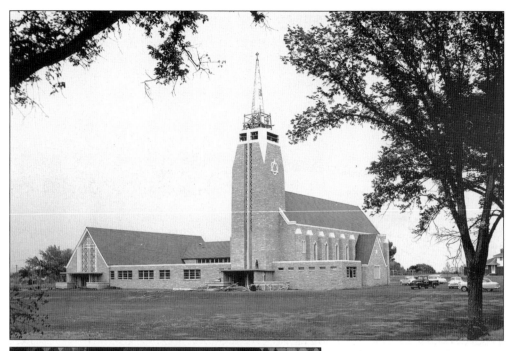

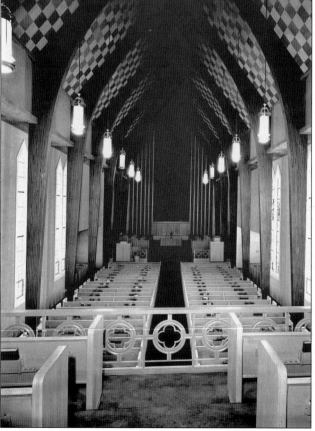

FIRST PRESBYTERIAN CHURCH, PONCA CITY. The congregation of the First Presbyterian Church moved into this modern building after over 30 years in the classical revival building shown on page 61. It was designed by Kansas architects Charles W. and John A. Shaver, assisted by Ponca City architect W. R. Brown. The modern Gothic style of the building is illustrated by the steeply pitched roof, with rafters that reach from the ground to the peak, known as a full-crock rafter in medieval architecture. The exterior of the building is clad with Arkansas harmony ledgestone from Clarksville, Arkansas, just like the Grace Episcopal Church to the east (see page 123). Jacoby Art Glass of St. Louis provided the stained glass. The tower reaches 128 feet into the heavens, and the nave seats 900. The complex cost the congregation $650,000.

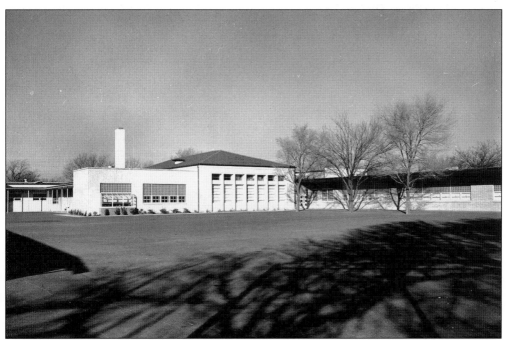

LINCOLN SCHOOL, PONCA CITY. This image of Lincoln School shows the extent of remodeling that occurred as a result of a 1948 bond issue (see original school, page 74). The architect for the $750,000 renovation was Ponca City architects Timberlake and Kanady. The entry has been simplified and the entire building transformed from the classical revival style to the modern style.

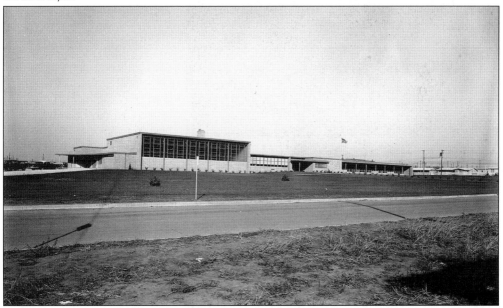

LIBERTY SCHOOL, PONCA CITY. Liberty School was constructed to serve the far north-central neighborhoods of Ponca City as part of an effort to renovate existing schools and build new schools where needed. Timberlake and Kanady were the architects for this school. It is in the modern style and was constructed in 1956.

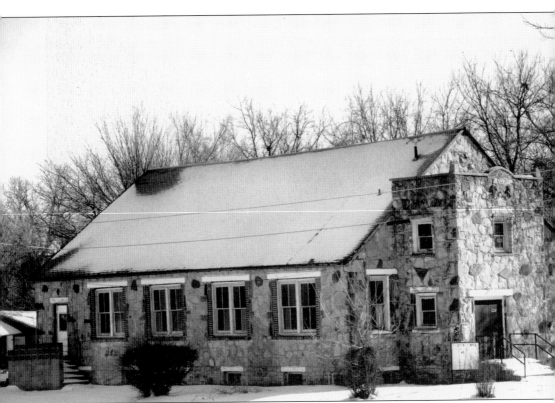

KIMBOROUGH AND COLORED METHODIST EPISCOPAL CHURCH, PONCA CITY. The Colored Methodist Episcopal Church was constructed of randomly laid native stone by the membership of the church in 1946. Former members recall laying brick in the basement after school. The vernacular stone building is accented with dark-colored rocks near the windows for decoration and a star created from several rock pieces over the simple entry. The interior had a cathedral ceiling and a balcony overlooking the sanctuary. Windows are of stained glass in a simple arrangement of four different colored panes in each of the four-over-four windows. The church enjoyed a strong membership for many years, and members were known for providing fried chicken dinners. People came from miles around for the Saturday evening dinners. The church stood empty for many years after members moved out of the neighborhood when segregation ended in the 1950s.

GRACE EPISCOPAL CHURCH, PONCA CITY. Built in 1952, the Grace Episcopal Church was designed by John Duncan Forsyth in the style of a rural English parish church. It was constructed using Arkansas harmony ledgestone. The entry doors have wrought iron hinges and are flanked with iron lanterns. The large building on the left was the Fellowship Hall at the original church location downtown.

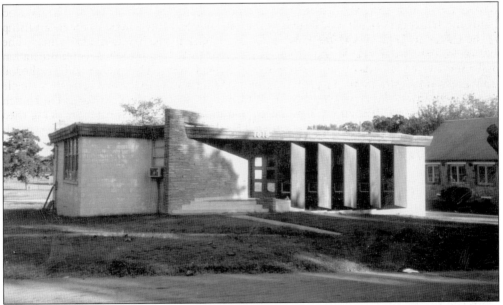

ATTUCKS LIBRARY, PONCA CITY. The Attucks Library, a branch of the Ponca City Public Library, was completed in 1953 at a cost of $32,000. The architects were Timberlake and Kanady of Ponca City. The modern style building is of concrete block, stone, and redwood. The front is given depth by the angled windows, with redwood sides protecting the windows from direct south and west sunlight.

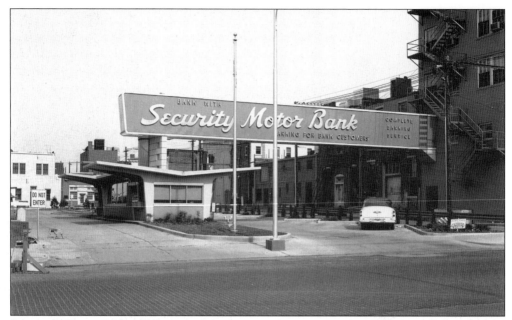

SECURITY BANK DRIVE-THROUGH, PONCA CITY (DEMOLISHED). Architects Timberlake and Kanady designed this small but very modern building as part of a large remodeling of the entire bank building in 1956. The freestanding drive-through bank was the first in Ponca City. With a V-shaped roof and large signage, it is evocative of the mid-century modern building beginning to gain appreciation today.

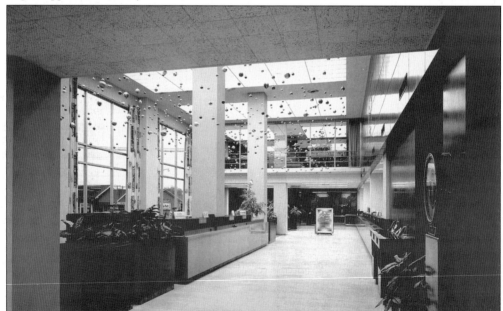

MASONIC BUILDING AND SECURITY BANK, PONCA CITY. By removing most of the mezzanine and opening up the space of the original lobby, architects Timberlake and Kanady created this soaring space inside the original Masonic building in 1956. The room features a ceiling of lighted panels and large columns. At this time, the original front door and awning were removed and the entry was rebuilt using marble.

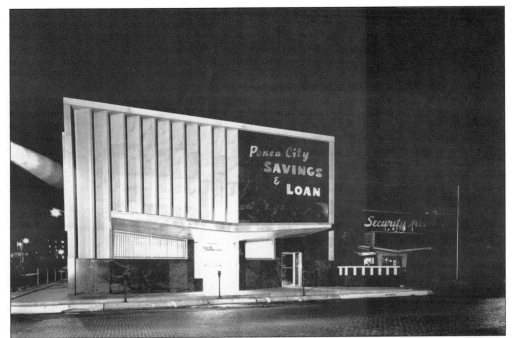

PONCA CITY SAVINGS AND LOAN. Located directly behind the Masonic building and its attached drive-through is this tour-de-force of mid-century modern architecture. The building was completed in 1956. The facade is dominated by the sweeping V-shaped awning, large signage on a marble panel, and louvered facade. The main building material for the bank is rose-colored granite. On the interior, the main room is accented with modernistic railings and a dropped ceiling, and it is lit by large expanses of fluorescent-lighted panels. Every room of the new Ponca City Savings and Loan building featured the most modern lighting fixtures and furniture.

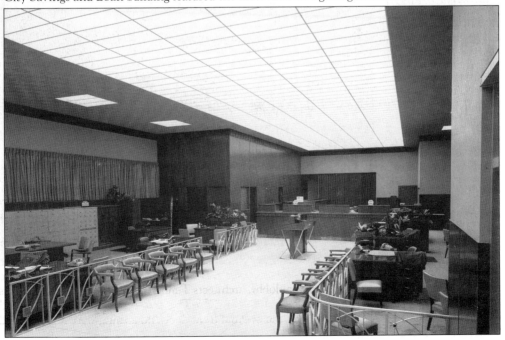

BIBLIOGRAPHY

Blackwell Centennial Board. *Blackwell: Jewel of the Chikaskia*. Blackwell, OK: Blackwell Printing and Stationary, 1993.

Dye, Karen. *Newkirk: Cast in Stone*. Stillwater, OK: New Forums Press, 1993.

Lomawaima, K. Tsianina. *They Called it Prairie Light: the Story of Chilocco Indian School*. Lincoln, NE: University of Nebraska Press, 1994.

Marlys Bush Thurber and Associates. *Gateway Historic District, Intensive level Architectural/Historic Survey*. September 2001.

McAlester, Virigina and Lee. *A Field Guide to American Houses*. New York, NY: Alfred A. Knoph, 1990.

North-Central Oklahoma Historical Association, Inc. *Rooted in the Past: Growing for the Future*. Topeka, KS: Jostens Printing and Publishing Division, 1995.

Ponca City Chapter, Daughters of the Revolution. *The Last Run*. Ponca City, OK: Courier Printing Company, 1939.

Tonkawa Lodge No. 157 A.F. & A.M. The First 67 Years of History. J. Morgan Bush.

INDEX

ACROSS AMERICA, PEOPLE ARE DISCOVERING SOMETHING WONDERFUL. *THEIR HERITAGE.*

Arcadia Publishing is the leading local history publisher in the United States. With more than 3,000 titles in print and hundreds of new titles released every year, Arcadia has extensive specialized experience chronicling the history of communities and celebrating America's hidden stories, bringing to life the people, places, and events from the past. To discover the history of other communities across the nation, please visit:

www.arcadiapublishing.com

Customized search tools allow you to find regional history books about the town where you grew up, the cities where your friends and family live, the town where your parents met, or even that retirement spot you've been dreaming about.